Helen Langdon

HOLBEIN

PHAIDON
Oxford

E.P. DUTTON
New York

The author and publishers would like to thank all those museum authorities and private owners who have kindly allowed works in their possession to be reproduced. Plates 22, 30, 32, 34, 36 and 37 are reproduced by gracious permission of Her Majesty the Queen.

Phaidon Press Limited, Littlegate House, St Ebbe's Street, Oxford
Published in the United States of America by E. P. Dutton & Co., Inc.

First published 1976

© 1976 Elsevier Publishing Projects SA, Lausanne/Smeets Illustrated Projects, Weert

ISBN 0 7148 1748 1
Library of Congress Catalog Card Number: 76–1347

Printed in The Netherlands

HOLBEIN

'Add but the voice and you have his whole self, that you may doubt whether the painter or the father has made him.' These confident words are inscribed on Hans Holbein's portrait of *Derich Born* (Plate 30); they, and the elegant young man who leans on the parapet, demand our admiration and compel our belief. It was this quality of life-like immediacy in portraiture that most impressed Holbein's contemporaries. Erasmus wrote to Thomas More, on the receipt of a drawing of More's family, '. . . it is so completely successful that I should scarcely be able to see you better if I were with you.' Today, our first reaction on looking at a Holbein portrait is perhaps still one of wonder at the sheer skill with which Holbein used all the technical resources of Renaissance naturalism to create an image of completely convincing accuracy. His patient observation of surface detail, of the texture of skin, hair and fabrics is combined with an ability to suggest weight and volume and a sense of the dignity of the human personality. Holbein's sitters are recorded exactly as they were at one particular moment, but there is never any stress on the transitory; they do not greet the spectator with gestures or turned heads; they do not impose their personalities upon us by any play of expression; rather they are characterized by an unusual stillness, precision and clarity. Holbein's eye was unerring, and his approach one of unparalleled objectivity. He rarely allowed any emotion to intrude.

Hans Holbein was born in Augsburg in 1497/8, and his working life may be divided into four periods. He worked in Basle and Lucerne from 1515 to 1526. From 1526 to 1528 he was in London, but returned to Basle for the next four years. From 1532 he was again in London and died of the plague there in 1543.

Little impression of Holbein's own personality emerges from his works. The facts of his life are well documented, but there are no surviving letters or journals which tell us about the man himself; although he knew many famous men of his time he is rarely mentioned in their letters except as a 'wonderful artist'. Best remembered as a portrait painter, he was in fact an immensely productive artist in a variety of mediums.

At the beginning of the sixteenth century German art hovered on the brink of the Renaissance. Throughout the fifteenth century north European artists had been concerned with a faithful imitation of nature, the greatest exponent of which was Jan van Eyck who had developed a brilliant technique of oil painting. His works are based on a tireless and meticulous study of the effects of light as it falls on patiently observed details of fabrics, metals, stone, flowers and grass. This feeling for the surface and texture of nature remained characteristic of the art of northern Europe for many years, and in this respect Holbein was truly the heir of van Eyck.

However, by the end of the fifteenth century, the splendour of the achievements of Italian artists of the Renaissance had begun to impress their northern contemporaries. Their own art must have begun to seem somewhat old-fashioned as they became increasingly aware of the Italian discovery of mathematical perspective, the Italian conception of the ideal beauty of the human figure (recreated from classical antiquity and based on the scientific study of anatomy) and the dignity

and grandeur of classical forms of building.

Albrecht Dürer, who was twenty-six years older than Holbein, was the first German artist to attempt to understand the new principles of Italian art. He visited Italy twice and thereafter his work was a struggle to introduce into German art something of the grandeur of the Italian High Renaissance. Dürer experimented tirelessly with Italian theories about proportion, perspective and anatomy; he tried to widen the narrow religious subject-matter of German art, introducing recondite allegories *esoteric* from classical mythology. Yet Dürer's works always remain recognizably Germanic; he was a melancholic, a man of intense religious convictions, and his art is full of the visionary and the fantastic. In sharp contrast to Holbein we know a lot about Dürer, who was fascinated by his own personality; he discussed himself in letters, journals and notebooks, and reveals himself through his art, as the cooler and enigmatic Holbein was never to do.

Dürer's only northern contemporary of comparable stature was Matthias Grünewald, who in every way represents a total contrast. Grünewald continued to work in the tradition of late medieval art, the aim of which was to communicate religious truths with intensity and passion. His most famous work was an altarpiece now called the *Isenheim Altar*. The central panel shows the Crucifixion, and rarely has this event been depicted with such stark cruelty. Every detail emphasizes the agony of Christ's suffering; the body, with the shoulders roughly pulled out of joint, hangs from a rough wooden cross; the decaying green flesh is covered with hideous scars; the hands are convulsed in agony. The painting is the culmination of a tradition of German Gothic paintings which show scenes from the Passion of Christ with the utmost brutality.

Landscape was another interest of German artists of this period. Lucas Cranach and Albrecht Altdorfer had discovered the beauty of the Alpine districts around the Danube and developed a kind of romantic landscape painting, often enlivened by dramatic effects of light. An interest in dramatic nocturnal scenes is also apparent in the works of Dürer's follower, Hans Baldung. Holbein was to become one of the most urban of artists, but, in his early religious paintings, he sometimes used romantic landscape backgrounds, and exciting contrasts of night and day. In other ways Holbein had little in common with his near contemporaries in Germany, all of whom were strongly individualistic. Hans Baldung, for example, moved away from the influence of Dürer to explore more shadowy areas of human experience – the erotic, the sensual, the demonic, and the libertine.

In a narrower context, Holbein's early training in Augsburg would have encouraged an interest in the Italian Renaissance. Augsburg was an important artistic centre, and artists of the preceding generation had begun to assimilate something of the Italian achievement. Hans Burgkmair had travelled to northern Italy, and had opened the eyes of Augsburg artists to the beauty of Renaissance architectural detail; he also experimented with Italian portrait types. Moreover, Holbein's father, Hans Holbein the Elder, was the leading artist of his generation in southern Germany; he was a late Gothic realist, whose capacity for precise and objective observation, particularly apparent in his numerous portrait drawings, anticipated something of his son's. His late altarpieces show the beginnings of a Renaissance interest in symmetry and a purely decorative use of Italian Renaissance architecture. Yet Holbein the Elder was also in touch with Grünewald, and in 1515 moved to Isenheim, when his son moved to Basle.

In Basle Holbein probably entered the workshop of Hans Herbst, with whom

4

his brother Ambrosius was working in 1516. In 1519 Ambrosius died; Holbein became a master of the Basle Guild in that year and probably took over his brother's workshop. About the same time he married Elsbeth Schmidt.

There was a continuing demand for church decorations in the old style in Basle, yet the city was also the centre of classical scholarship and of the European book trade. Johann Froben, friend of Erasmus and publisher of his books, established his press there, and Holbein began to produce book illustrations for him in 1516. In these early years Holbein, not surprisingly, veers between the old and the new. His religious paintings have an expressionist figure style and a violent subjectivity that suggest that he had studied Grünewald; yet he also studied with enthusiasm engravings of classical forms and used them sensitively in his work, often combining details of both classical and Gothic architecture in the same painting. The knowledge that Dürer had struggled so painfully to acquire was more accessible to the younger Holbein. To no other German artist did the potentials of scientific perspective reveal so much.

Holbein was a precocious artist, with an astonishingly mature grasp of form, and in his early works there is an element of exuberant display and delight in a complex treatment of space. He experimented ceaselessly with new problems, applying linear perspective even to book illustration and portraits. In his religious paintings, sweeping movements into depth create effects that are almost melodramatic; his decorative paintings use feigned architecture in a way that approaches *trompe l'oeil*, and are full of wit, gaiety and humour. In these early paintings we can most immediately feel the excitement of the boundless possibilities revealed to a northern artist of this period by the Italian discoveries of the *quattrocento*.

Despite his youth, Holbein was immediately accepted into humanist circles in Basle. He made his artistic début with some informal marginal drawings that he did in a first edition of Erasmus's *Praise of Folly* of 1515, which later belonged to Erasmus himself. These are remarkable for their wit, humanity and instinctive sympathy with the spirit of Erasmus's irony.

In the following year, although a young and unknown artist, Holbein attracted the patronage of the rich merchant classes, and painted the burgomaster *Jakob Meyer* and his wife *Dorothea Kannengiesser* (Plates 2, 3). Meyer was later to head the Catholic party in opposition to the reformers, and to commission from Holbein his greatest religious work (Plate 14). The composition of the Meyer portraits is based on a *chiaroscuro* woodcut of Hans Baumgartner by Hans Burgkmair; husband and wife are shown against one continuous architectural background which is sumptuous in its elaborate detail and contrasts of red and gold. In this, the first portrait in which Holbein experimented with perspective to create depth, the architecture thrusts forcefully into space. Holbein was always to be far more inventive in his creation of new portrait types than Dürer had been. The bright reds against the blue of the sky, and the elaborate display of gold embroidery and jewellery, emphasize the effects of brilliance created by the architecture. Framed by this fashionably classical setting, the features of the couple remain stubbornly unidealized and sharply observed. They are close in feeling and in pose – particularly in the pose of the woman, with her hands concealed and her arms held away from the body – to the likenesses made by Holbein the Elder. It is a remarkably confident painting for so young an artist.

The showy qualities of the Meyer diptych have been eliminated from the portrait of *Bonifacius Amerbach* of 1519, which is a simpler and more striking work (Plate 4).

Amerbach, a close friend of Erasmus, was Professor of Roman Law at Basle University, and owned many works by Holbein which later formed the basis of the famous collection now at Basle. Amerbach dominates his surroundings. The poem, composed by himself, which praises the lifelikeness of the portrait, leads the eye gently into space; the dress is elegantly unobtrusive. The portrait is not prosaically realistic but has a new dignity which expresses something of the humanist confidence in the power of man's intellect.

From 1517 to 1519 Holbein worked in Lucerne, where he collaborated with his father on the decorations for the magistrate's residence, the Hertenstein House, now destroyed. This was the first of a series of decorations in which Holbein exploited the possibilities of illusionistic architecture, and which included a pageant scene heavily dependent on engravings after Mantegna's *Triumphs*. It is almost certain that sometime during these two years Holbein went to northern Italy; paintings of the 1520s, such as the *Lais Corinthiaca* (Plate 12) and the group portrait of Sir Thomas More's family, suggest a direct knowledge of works by Leonardo and Mantegna.

Holbein's early religious works show the influence of Dürer, Grünewald and Hans Baldung. The *Adam and Eve* of 1517 (Plate 1) is based on a woodcut by Dürer of 1510, which shows Adam and Eve embracing as Eve takes the apple; in Holbein's painting the tender melancholy of Adam's expression seems to suggest his awareness of the ensuing tragedy.

The figures in *Christ as the Man of Sorrows* and the *Mater Dolorosa* are also Düreresque; the complex architectural background plunges into space and, though the forms are classical, the sweeping movements and clash of geometrical shapes increase the emotional fervour; it is an idiosyncratic combination of southern forms with Germanic feeling. A further group of works from this period show scenes in which classical architecture is illuminated with dramatic, often nocturnal, lighting effects.

In the early 1520s Holbein achieved a truer balance between north and south. His *Dead Christ* of 1521 (Plate 8) is unimaginable without the example of Grünewald, yet nowhere is Holbein's capacity for detached and merciless observation more apparent. His painting makes no overt appeal to the emotions, there is no exaggeration of bodily agony in expression or gesture; yet it does move us to pity and fear because of its painfully accurate and unflinching description of the structure of the body, the putrid and decaying flesh turning green around the wounds, the swollen lips, sunken eyes and rigid hands.

The two shutters of an altarpiece (Plate 5) conclude this early phase of Holbein's development. Although the format and subject recall earlier German paintings, Holbein here tells the story of the Passion of Christ with a straightforward and human directness that is new in German art; the figures have lost the spikiness and bonelessness of the late Gothic style and become sturdy and compact, standing firmly on the ground. Both Christ and his persecutors are humanized, and Christ himself is no longer a pallid and pure victim. Holbein stresses the passionate intensity of his suffering in the garden, and the reluctant knowledge with which he submits to Judas' extravagant embrace; perhaps most astonishing is the unemotional representation of his body on the cross. Nor are his persecutors snarling animals in extravagant medieval armour; they are calm and grave, wear Roman dress, and their elegant poses recall Mantegna. *The Entombment* is based on Raphael's composition in the Borghese, but Holbein has broken up the classic grace and flowing movement of Raphael's painting in the interests of a starker realism.

6

In the *Meyer Madonna* of 1526 (Plate 14) all remnants of a Gothic format have gone; of all Holbein's paintings this most nearly approaches the grandeur and calm symmetry of Italian Renaissance compositions. The painting shows the Madonna of Mercy sheltering the praying family of Jakob Meyer beneath her cloak. In 1526 the two sons died, and between 1528 and 1530 Holbein added the profile portrait of Meyer's first wife, thus commemorating Jakob Meyer's whole family. The portraits retain a northern realism, but their expressions and taut poses suggest a spirituality that is far removed from the worldliness of the earlier Meyer portraits (Plates 2, 3). The painting has an unusual combination of the majestic and the intimate; the composition is open and the group of figures brought close to the world of the spectator.

The soft painting of the flesh in the *Meyer Madonna* reveals the influence of Leonardo, whose work continued to interest Holbein throughout the 1520s. Nowhere is this more apparent than in the *Lais Corinthiaca* of 1526 (Plate 12), for which Holbein used the same model. Both the subject-matter – the model is shown as a Greek hetaira (dancing-girl) – and the overtly Italianate quality, which suggests Raphael as well as Leonardo, are unusual in Holbein's work.

Up till this period Holbein's career had been immensely varied and extremely productive; as well as portraits and religious paintings, he had produced designs for painted glass, woodcuts, façade decorations, and, in 1521–2, he had begun a series of wall paintings in the great Council Chamber of Basle town hall, which, within a framework of feigned architecture, showed scenes from classical history intended to advise the councillors.

Before 1526 he had produced a series of woodcuts illustrating the *Dance of Death*. Holbein's ironic tone throughout the series contrasts sharply with contemporary, more expressionist treatments of the subject. Death appears as a mocker, attacking every class of humanity and – as he snatches the Emperor's crown during the distribution of Justice, and fixes around the countess's neck a chain of bones while she makes a lavish toilet – revealing the futility of worldly power and concerns. Some of the same social types are also shown on a design for a dagger sheath, where Holbein shows the dead and the living dancing together. The series is remarkable for its variety and for the precision of Holbein's feeling for different social types.

By the mid-1520s, however, the violent disturbances associated with the Reformation put an end to this productivity. Religious paintings were viewed with disfavour and Holbein decided to look for work in England.

The choice of England was perhaps encouraged by Erasmus, and his portraits of Erasmus form the prelude to the humanist portraits of Holbein's first English period. Erasmus settled in Basle in 1521 and Holbein supplied his publisher, Froben, with woodcuts for his books. Erasmus was the most famous classical scholar in Europe, sought after by princes and high churchmen; his portrait was done by many artists – amongst them Dürer and Quentin Massys – yet today we cannot imagine him without thinking of Holbein, in whom we sense a deep understanding of his irony, detachment, wit and seriousness.

Erasmus was attracted by the idea of exchanging portraits with his friends; he had already presented Sir Thomas More with a double portrait of himself and Petrus Aegidius by Quentin Massys. In 1524 Holbein took a portrait of him to France; in the same year two portraits by Holbein were sent to England, one of which was presented to Archbishop Warham.

In the fifteenth-century portraits of scholars, usually St. Augustine or St. Jerome, surrounded by books and writing materials, were common. In the sixteenth-century this portrait type was adapted to the humanist scholar, and Massys's and Holbein's portraits of scholars are variations on this theme. Massys tends to be more informal, and to attempt to create something of the atmosphere of the study. Holbein's portraits of Erasmus are more definitive celebrations of the supreme scholar. In the painting in the Louvre (Plate 11) Erasmus is shown in profile, writing at his desk; no details distract from this portrayal of a powerful intelligence, and the charmingly decorative background adds a touch of intimacy and acts as a foil to the powerful modelling of the head.

In 1526 Holbein left for England. He carried with him a letter of recommendation from Erasmus to the Antwerp scholar Petrus Aegidius, asking the latter to introduce him to Quentin Massys. 'The arts are freezing in this part of the world', wrote Erasmus, 'and he is on his way to England to pick up some angels there.' Holbein probably also carried letters to Erasmus's friends in England.

Holbein's belief that England was the home of the arts at this time was not without justification. Henry VIII's reign had opened full of promise for the revival of classical learning; John Colet, who had travelled in Italy, was lecturing at Oxford from 1496 to 1504; Warham, Erasmus's friend and patron, was Archbishop of Canterbury; Wolsey had established himself as a great patron of learning and was encouraging Italian craftsmen and sculptors to work in England; poets flocked to Henry's court, and Wyatt and Surrey were introducing the Petrarchan sonnet. Sir Thomas More, after the publication of his *Utopia* in 1516, achieved a fame in Europe that paralleled that of Erasmus.

More exchanged letters with the greatest scholars of his day, amongst them Erasmus, Vives and Cranevelt, and was visited by them. Erasmus himself visited England several times in the early years of the century and was tempted to settle there; his letters give some idea of the atmosphere of optimism and hope with which the humanists awaited the rule of reason, learning, moderation and mercy. In 1499 he wrote to Robert Fisher, 'And I have met with so much learning, not hackneyed and trivial, but deep, exact, ancient Latin and Greek, that I am not hankering so much after Italy except just for the sake of seeing it. When I hear my Colet, I seem to be listening to Plato himself. In Grocyn who does not wonder at that perfect compass of all knowledge? What is more acute, more profound, more keen than the judgement of Linacre? What could nature ever create milder, sweeter or happier than the genius of Thomas More?' In 1518 Erasmus wrote to Henry VIII, praising him for his establishment of a Golden Age of universal peace, justice and scholarship.

Holbein arrived in England in 1526; More, who had been established in a position of power at court since 1521, wrote discouragingly to Erasmus, 'Your painter, dearest Erasmus, is a wonderful man; but I fear he won't find England as fruitful as he had hoped. Yet I will do my best to see that he does not find it absolutely barren.' More was, of course, aware of the lack of any tradition of portrait painting in England; he was probably also aware of the troubled times to come; the Reformation, which had caused Holbein's departure from Basle, was soon to reach England. However, More kept his word, and for the best part of the years 1526–8, Holbein stayed in Chelsea, painting More, his family and friends.

Holbein's portraits from this first short stay in England have a particular interest in that they capture much of the dignity and nobility of More and his circle in

this period of hope. The portraits are characterized by a warmth of human feeling and by an undramatic presentation that convinces us of its complete truthfulness. They are perhaps the most approachable of Holbein's portraits; the flawlessness of his technique, the patient description of details which create these superbly realistic likenesses, does not call attention to its own perfection as it tended to do in the later portraits.

The portrait of *Sir Thomas More* (Plate 20) dates from 1527. Compared with the earlier portraits of Erasmus, this painting has a new monumentality and grandeur; the body confidently fills a space clearly defined by parapet and curtains. It is one of Holbein's most direct and precise portraits, and shows his meticulous observation of surface texture, of the wrinkles around the eyes and nose and the stubble on the chin. Yet it also has a dignity that we associate with the great portraits of the Italian Renaissance, with Raphael's *Castiglione* (Paris, Louvre) or Titian's *Ariosto* (London, National Gallery). More is here the statesman, wearing rich dress and the chain which was an emblem of service to the king; yet we also feel in the stillness of the pose, and in the latent vitality of his features and hands, a sense of the restrained intellectual power of the scholar.

In the same year Holbein also painted William Warham, Archbishop of Canterbury (Paris, Louvre). As we have seen, Warham owned one of Holbein's portraits of Erasmus (now at Longford Castle) and he had himself painted in the same pose; the portrait was intended as a return gift.

To the same period belongs the superb portrait of an *Unknown Lady with a Squirrel and a Starling* (Plate 21). The monumental design and delicate treatment of detail link it with the portrait of *Sir Thomas More* (Plate 20). The suggestion of quiet dignity is common to both. The brilliant description of the squirrel, complete with a small chain held in the lady's hands, shows the breadth of Holbein's skill and sympathies.

The portrait of *Nicolas Kratzer* (Plate 27), astronomer to Henry VIII, tutor to the children of Thomas More, friend of Dürer and life-long friend of Holbein himself, dates from 1528. Kratzer is shown, posed in a quiet moment of thought, surrounded by the instruments of his profession; the still-life attracts almost as much attention as the sitter. To the English, unaccustomed to the wonders of Renaissance naturalism, the accuracy of Holbein's treatment of the still-life must have been startling. Careful attention is paid to the texture, size, lighting, and exact location in space of every object; the *trompe l'oeil* painting of the objects hanging on the wall must have seemed little short of miraculous.

The most worldly of the portraits of the period are the pair of *Sir Henry Guildford*, Controller of the Royal Household (Plate 22), and *Lady Guildford* (Plate 23), both dated 1527. An impression of bulk and weight dominates both paintings; Sir Henry's dress in particular is rich and lavish, and much gold paint has been used in the costume and in the collar of the garter. A drawn curtain defines the space behind Sir Henry, a Renaissance column with tie-beam the space behind Lady Guildford.

This handful of portraits is all that remains of Holbein's first English period. His most remarkable work was a large group portrait of Sir Thomas More's family, which has since been destroyed. It measured eight feet high and thirteen across, and was painted in watercolour on linen or canvas. We know what it looked like from a pen-sketch by Holbein of the composition (Basle), which was sent to Erasmus in 1526, and from an old copy by Richard Locky painted in 1530. The painting showed More and his father seated in the centre, surrounded by their family; they

9

were shown reading, or discussing, or pointing out interesting details to each other in classical texts. The painting must have recreated much of the atmosphere of More's remarkably scholarly household, in which women as well as men received a classical education, and which Erasmus, in a famous letter, described as Plato's Academy on a Christian footing. The painting was the first large-scale portrait-group done in northern Europe and suggests that Holbein knew Mantegna's frescoes of the Gonzaga family in Mantua.

Holbein had been given only two years leave of absence by the authorities in Basle and in 1528 returned there and bought a house. In 1529, however, the full fury of the Reformation reached Basle. The City Guild ordered all paintings to be taken out of the churches and destroyed. Holbein seems eventually to have complied with the Reformers, yet that he had doubts may be inferred from a document of 1530 in which Holbein asked to be given a better explanation of the Last Supper before partaking of the Lutheran Communion.

Holbein was not completely inactive over the next four years. He did further work on the Council Chamber decorations in Basle town hall; he produced designs for book illustrations and stained glass; he painted Erasmus again. It seems likely, too, that during this period he revisited north Italy, for in the early 1530s there seems to be a renewed influence in Holbein's work from the portraits of Raphael and Leonardo. By 1532, however, he seems to have realized that there was little possibility of finding a fruitful source of patronage, and he returned to England.

One of Holbein's most moving paintings dates from this second Basle period, that of his wife and two children (Plate 10). Of all Holbein's portraits this is the most emotionally expressive, particularly in the suffering face of the mother and in the painfully anxious but expectant faces of the children. The beautifully integrated composition was suggested by the traditional Italian format for paintings of Mary with Christ and John the Baptist; the classic structure and this allusion to a religious theme give the portrait a weight and significance that reaches beyond the personal.

The England of 1532 was dramatically different from that of 1528. Holbein fled from the Reformation in Basle to find England on the edge of a revolution. Henry VIII's desire to marry Anne Boleyn and divorce Catharine of Aragon had led him to break with Rome and to claim Imperial status for the kings of England: in 1534 the Act of Supremacy, which gave the Crown authority over the affairs of the Church of England, was passed. Almost all Holbein's earlier patrons became involved in the ensuing disturbances. Warham and Guildford died in 1532; More resigned from the chancellorship and was to be executed in 1535 for refusing to take the oath required by the Act of Supremacy; Surrey was executed and Wyatt imprisoned. Henry VIII had effectively put an end to the development of classical scholarship in England.

Thus it was imperative that Holbein should find new sources of patronage, and between 1532 and 1536 most of Holbein's patrons were members of a trading community in London, merchants of the German Steelyard. For their procession to celebrate Anne Boleyn's coronation he designed a triumphal arch depicting Apollo and the Muses. He also painted two large wall decorations on canvas, *The Triumph of Riches* and *The Triumph of Poverty*, for their hall, which became famous throughout Europe. For the most part, however, his commissions were for small half-length portraits, in which the sitter is shown in his office, often with his accessories of work scattered about, and holding a letter bearing his name and address.

The earliest of these, dated 1532, is of the Hanseatic merchant *Georg Gisze of*

Danzig (Plate 24). The portrait is unusually elaborate, and the brilliance of the *trompe l'oeil* still-life suggests that Holbein was deliberately exhibiting his skill to attract further commissions. In 1533 he painted *Derich Born* (Plate 30), a portrait of supremely confident elegance, in which the pose suggests the renewed influence of Raphael and Leonardo. As in Leonardo's *Mona Lisa* (Paris, Louvre), the head faces outwards, while the body is turned to the side, and the near arm brought close to the picture plane. In the same year Holbein painted *Robert Cheseman* (Plate 26), and here Holbein used the plain background with the gold lettering that became frequent in the later years; the impression of depth is created by the figure alone. In a sense both these paintings are transitional works, which combine something of the amplitude of the earlier English portraits with the sharper contours and more perfectly rounded forms and abstract settings of the later period.

A very different work from this period, *The Ambassadors* of 1533 (Plate 15), also showed foreigners in England. This ambitious painting is a life-size double portrait of Jean de Dinteville, French Ambassador to London, and Georges de Selve, the Bishop of Lavour. Between them are two shelves covered with an array of objects, which indicate their knowledge of sciences, religion and the arts. At first sight the grand scale and superb realism of the painting make it appear an overwhelming statement about Man's potential and attainment; yet the heraldic symmetry of the composition is roughly broken into by the blurred shape that obscures part of the mosaic floor. This is a human skull, painted in a distorted perspective, which assumes its true shape when seen from the bottom right corner. This reminder of death is taken up in other details of the painting. There is a crucifix in the top left corner; the badge on de Dinteville's hat shows a human skull; and the string on the lute is broken. The painting thus celebrates Man's power whilst at the same time reminding us of the ultimate futility of human endeavour.

The portrait of Jean de Dinteville's successor, as ambassador to the English court, *Charles de Solier, Sire de Morette* (Plate 25), shows a comparable richness and amplitude. The *Unknown Gentleman with Music Books and Lute* (Plate 31) is also shown against a curtain; its folds add visual interest to the background. However, the later portraits of the merchants of the German Steelyard tend to be simpler; the mood one of restraint and quiet dignity. This tendency towards simplicity, and the elimination of all accessories, is characteristic of his late portraits. After 1535 the sitters are usually shown in the full light, focused against a background of blue or green, and very often in simple frontal poses. Holbein was, through a reduction of means, seeking a more abstract beauty of form. Nothing distracts from the clarity of his contours, nor from the perfection of the technique with which he describes, brush-stroke by brush-stroke, details of hair, skin and fabrics. There is a quality of stillness and remoteness in the late portraits.

The change in Holbein's style may be clearly seen in the portrait of *Sir Richard Southwell* of 1536 (Plate 33). The line here detaches itself far more sharply from the background than hitherto, and relentlessly circumscribes Southwell's rather unpleasant and self-satisfied expression. Southwell had helped to betray Sir Thomas More, and it is at this stage in Holbein's career that we fully understand of how coldly detached he could be.

In yet later portraits the sitter tends to become larger in relationship to the picture plane, as in the portrait of *Anton the Good, Duke of Lorraine* (Plate 46). We become more conscious of the part that the frame plays in relating the sitter to the picture plane; the panels are smaller, and there is an impression of increased

concentration and precision. The *Unknown Young Man at his Office Desk* (Plate 47) is a superb example.

The portraits of English royalty form rather a separate category in his work. Somewhat surprisingly he did not enter the royal service until 1537, but his potential seems to have been recognized by Thomas Cromwell, whom he painted in 1534. Cromwell, throughout the 1530s, with the aid of a team of pamphleteers, was carrying out a propaganda campaign to create an image of royalty so powerful that it should compel the loyalty formerly reserved for the more ancient power of Rome. His master-stroke, perhaps, was to realize how Holbein could communicate these new concepts in paint, and it is Holbein's vision of Henry VIII, massive, ruthless and dominating, that still persists today.

Holbein's royal portraits, then, concentrate on the expression of an idea, and for them he evolved a style which depends on the rich patterning of dress and jewellery. The bodies no longer occupy space but are schematized, and the surfaces encrusted with glowing decorative detail which seem to take on a ceremonial significance; the whole has the effect of an icon, of a hieratic image of royalty.

Although Holbein created a standard type for portraits of Henry VIII, only one portrait of him is now accepted by all scholars as being from Holbein's own hand. This painting (Plate 38) was almost certainly the pair to the portrait of *Jane Seymour*, Henry's third wife (The Hague, Mauritshuis). Amidst the linear flatness of her dress, Jane Seymour's face does retain some character, albeit of rather prim timidity. Henry's massive head is depicted without warmth, and expresses the merciless power he possessed.

In 1537 Holbein executed a large wall painting for the Privy Chamber in the palace of Whitehall, now destroyed. This showed Henry – with Jane Seymour, Henry VII and Elizabeth of York – as head of the Tudor dynasty; Henry himself was shown life-size in a dominating frontal stance with legs apart. It is not surprising to read in an early account that visitors were 'abashed, annihilated' in his presence. Henry's supreme power was also the subject of a miniature which shows him as *Solomon Receiving the Homage of the Queen of Sheba* (Plate 34).

In 1537 Jane Seymour died after the birth of the future Edward VI. Immediately Henry, aided by Cromwell, began to look for a new wife, ideally one that should combine political advantage with Henry's desire for physical beauty. Henry's idea was that all the possible brides in France should be brought to the French coast and inspected by him; not surprisingly this idea was rejected by François I. Henry therefore decided to send Holbein to paint all candidates for his hand and throughout 1538 and 1539 Holbein was occupied with this commission.

His first journey was to Brussels, in 1538, to paint Christina of Denmark, the widowed Duchess of Milan; the marriage negotiations, however, came to nothing. Later in 1538 Holbein set off for France to paint Renée of Guise and Anne of Lorraine. After this journey he returned to Basle for a month, where he was fêted by his fellow-citizens. The City Guild unsuccessfully tried to retain his services with offers of a pension, two years leave of absence, and liberal conditions of work. In 1539 Holbein was sent to Düren to paint two daughters of the Duke of Cleves, Anne and Amelia. Henry VIII finally married Anne of Cleves in 1540; but, ironically, after all his precautions, he developed a violent physical aversion to her and divorced her a few months later.

The most successful result of these journeys is the portrait of *Christina of Denmark* (Plate 43). His achievement is all the more astonishing when we realize that he

was granted a sitting of only three hours, during which he probably made a likeness in chalk or watercolours, working it up into a full-length portrait after his return to England. Amongst Holbein's royal portraits the painting is remarkable for its fresh perception of the individual, whilst retaining all the formality of the state portrait. The sitter gazes directly at the spectator; her features are soft and sensitive, seemingly capable of movement and expression. Christina, touchingly youthful in her widow's robes, is not locked into a flat pattern of dress and jewellery. Her solid form stands away from the brightness of the background and casts a shadow against it. There is even a suggestion of movement in the way that her dress clusters around her feet. The beauty of the effects that Holbein has here created with a daringly simple composition and a narrow yet beautifully modulated range of colours and texture, is still more remarkable if we remember his earlier taste for a display of complexity.

The portrait of *Anne of Cleves* (Plate 42) has none of the vivacity of the *Christina of Denmark*. The painting is in watercolour on parchment and shows Anne of Cleves in her wedding clothes. Holbein probably sketched her whilst in Düren and later elaborated it into a marriage portrait. The painting is severely formal, and a splendid decorative array of reds and golds is set against the plain green background; face and hands are absorbed into the overall effect and there is little impression of character or individuality.

The portrait of *De Vos van Steenwijk* (Plate 39), like the *Christina of Denmark* (Plate 43), shows well the relaxed mastery of his later work. All Holbein's skill is now lavished on such details as the hairs in the beard, the eyelashes and the pattern on the lapels of the surcoat. The desire – perhaps even need – to display technical virtuosity, so evident in *The Ambassadors* (Plate 15), has passed, creating an image that is as compact as it is uncluttered.

Holbein not only created the official image of Henry VIII, which has kept its hold on the popular imagination until the present day, but also captured the whole atmosphere of the Tudor court as it passed through one of the most dramatic periods of English history. There survives, as well as several paintings of the men and women who surrounded Henry VIII, the famous volume of drawings now preserved in the Royal Library at Windsor Castle, which almost certainly remained in Holbein's studio until his death. This contains eighty-five portrait drawings of men who played a leading part in the making of Tudor history; only a few of the drawings may be connected with surviving paintings. Where the paintings are known, however, they frequently follow the drawings very closely indeed; for example, the painting of *Sir Richard Southwell* (Plate 33) follows the drawing (Plate 32), even down to such details as the rather casual arrangement of the buttons in the collar. Drawing had always been the basis of Holbein's style and these portrait drawings are not quick sketches or impressions, but carefully worked-out statements about the sitter's personality.

These drawings, naturally, have a particular interest for an English public in that they supply us with a detailed description of the most famous and glamorous personalities from the reign of Henry VIII. They include physicians, maids-in-waiting, military commanders, poets and men of letters, amongst them Wyatt, Surrey and Sir Thomas Elyot, author of the *Governor*, who retired from the dangerous world of politics when he heard of the execution of his friend Sir Thomas More (Plate 20). It also includes men who were involved in diplomacy and affairs of state – More himself, protégés of the Lord Chancellor, Thomas Cromwell, amongst them

Southwell and Sir John Godsalve.

The drawings reflect a turbulent and troubled time, and it is interesting, on looking through the volume, to see how many of these men who held positions of power were arrested for treason, and how many were executed. Holbein's unerring feeling for types of humanity moves with ease from the noble calm of More and his circle to the tough ambition and capacity for cold intrigue that is present in the faces of some of Cromwell's circle. Occasionally, with a meticulous technique, he shows the dandified and langorous elegance of the court hanger-on, as in the portrait of *Simon George of Quocote* (Plate 41), for which there is a drawing at Windsor.

The only other English king who attracted an artist of such genius to his court was Charles I, and a comparison between the achievement of Van Dyck and Holbein is perhaps illuminating. Van Dyck's success depended on his sympathy with the poetic sensibilities of those around him; he seems to have submerged himself in the ethos of the Caroline court and put into paint all the glamour and grace of that court's vision of itself. Van Dyck's portraits of elegant cavaliers and their ladies, standing on terraces before columns and velvet curtains, tend to blur together in our minds; it is the beauty of the idea that we remember. With Holbein the reverse is true; we remember a series of immensely vital and immediately convincing personalities recorded without poetry and without flattery by an artist whose rigorous discipline and grasp of essentials allowed no sentiment to intrude. His drawings stubbornly emphasize the core of the human personality and concentrate on the individuality of the sitters.

Stylistically, the drawings, as we might expect, follow much the same development as the paintings. Those of the first English period are the most broadly conceived and boldly handled. Sketched on white paper in black and coloured chalks, they have a grandeur and nobility that is lacking from the later drawings. From the 1530s Holbein used paper primed with carnation, modelling the features in black chalk and adding details of the hair and ornaments in Indian ink with either the brush or pen. The beginning of this more refined technique is apparent in the drawings of the early 1530s, as in those of *Sir Thomas Elyot* and *Lady Elyot* (Plates 36, 37), where the penwork has a new subtlety and delicacy. Occasionally in the later 1530s Holbein made very elaborate drawings with minutely precise detail; more commonly, particularly in drawings associated with royalty where presumably the sittings were brief, the tendency is to eliminate all detail and to concentrate solely on a schematic outline. For some of his later portraits Holbein seems to have used a mechanical tracing device.

Holbein's work for the English court did not stop at portraits; he also produced designs for court dress, necklaces, jewellery (Plate 40), hat-badges and brooches. More than two hundred and fifty designs for craftsmen, particularly goldsmiths, are attributed to him, and he was responsible for much of the plate and weapons in use at Henry's court. His decorative style shows a delight in flowing Renaissance forms of exuberant and sophisticated complexity that contrasts sharply with the direct realism of his portraits.

The most lavish and ornate design for goldsmith's work now surviving is *Jane Seymour's Cup* (Plate 35), which was ordered by Henry when he married Jane Seymour in 1536. The initials of Henry and Jane, entwined with true-lovers knots, are set in the hand beneath the four circular medallions containing busts *all' antica*. A hand round the stem contains the queen's motto: 'Bound to obey and serve', which is repeated on the cover. The design has all the grace and stylish refinement that

we associate with European mannerism; few other examples of such calibre were to find their way to England.

It was also in England that Holbein began to paint portrait miniatures. He seems to have learned the technique from an artist called Lucas Horenbolt, a Flemish painter in the service of Henry VIII. Holbein's miniatures do not differ essentially from his large-scale paintings; his famous miniature of *Mrs Pemberton* has all the precision of line and clarity of structure of larger portraits. Holbein's miniatures were to be praised by the most famous English miniaturist, Nicholas Hilliard, who later in the century wrote, 'Holbein's maner of limning I have ever imitated and howld it for the best.' Hilliard's miniatures, however, transform the miniature from the reduction of a large-scale painting into a jewel-like and daintily patterned *objet d'art*.

Holbein died in 1543, at a comparatively early age. He did not, as Van Dyck was later to do, redirect the course of English painting. Although the Elizabethan interest in pattern may owe something to Holbein's royal portraits, his style was not easily imitated. His clinical insistence on truthfully recording what he saw could not create a fashion as could Van Dyck's romanticizing approach to his subjects. But the men that Holbein painted still live for us through his eyes. The portraits of Henry VIII and Thomas Cromwell represent totally different aspects of humanity from those embodied in Erasmus and More, yet Holbein created the definitive images of all four men, and this is perhaps the measure of his detachment. The portraits of More and Cromwell, placed side by side, pin-point and hold for ever a turning point in English history.

List of Plates

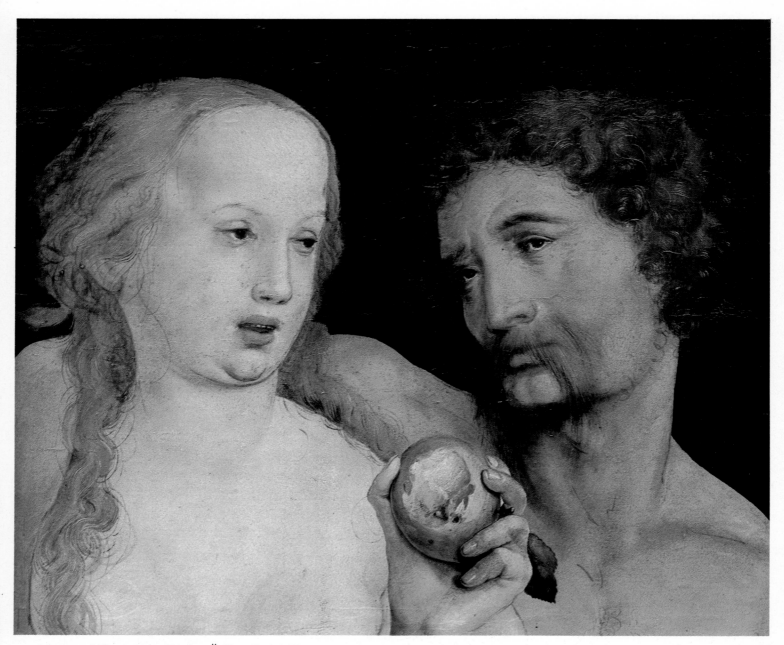

1. *Adam and Eve.* 1517. Basle, Öffentliche Kunstsammlung

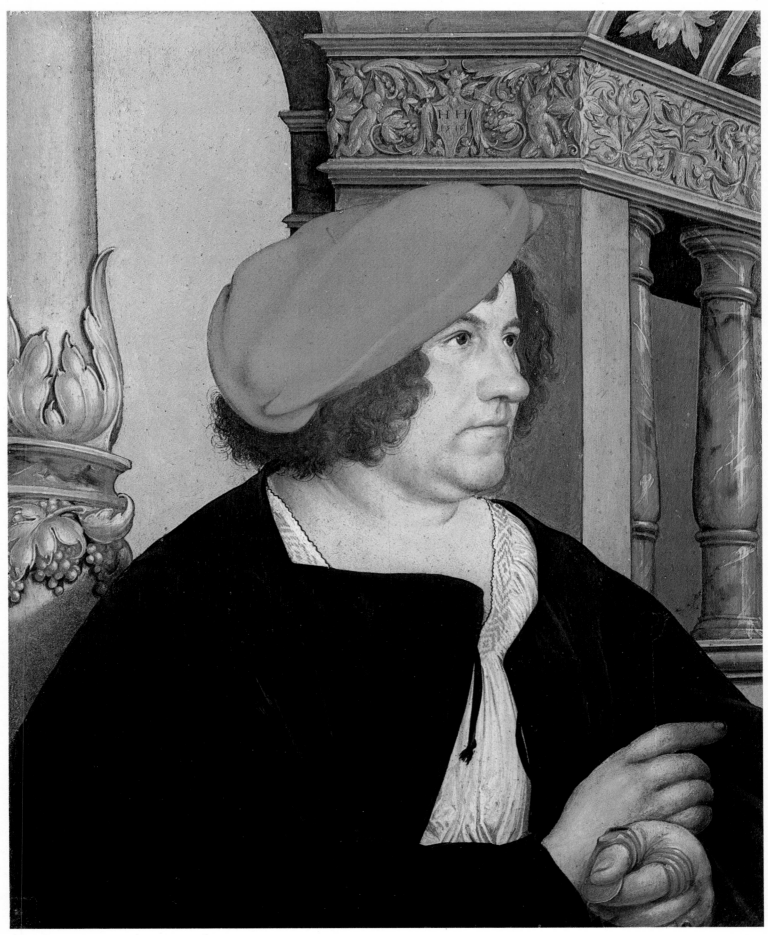

2. *Jakob Meyer*. 1516. Basle, Öffentliche Kunstsammlung

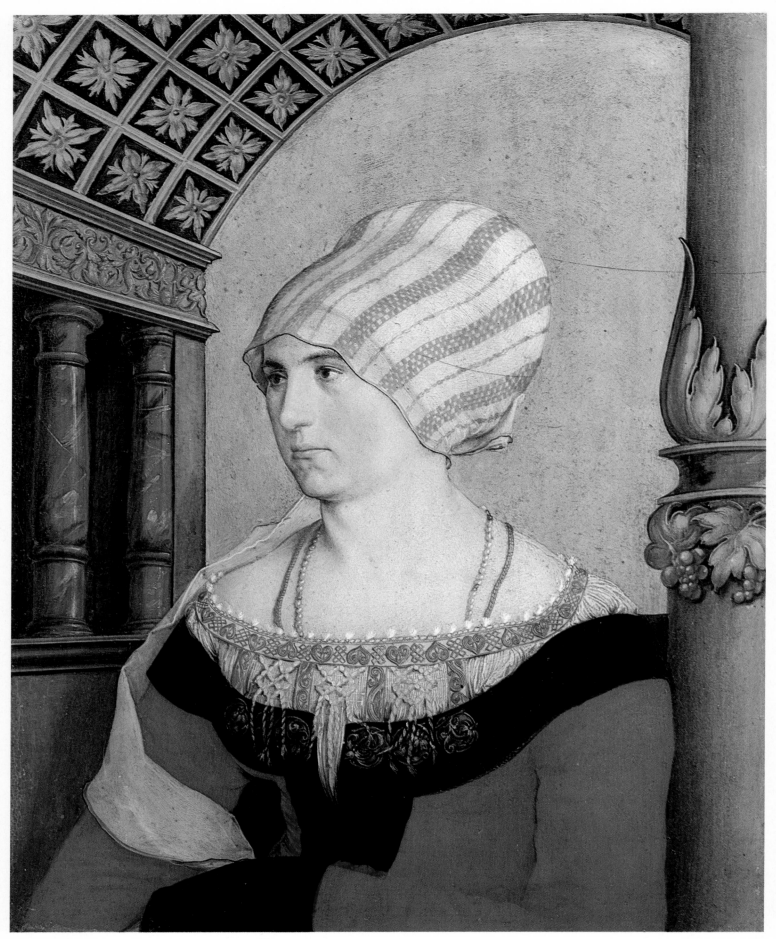

3. *Dorothea Kannengiesser*. 1516. Basle, Öffentliche Kunstsammlung

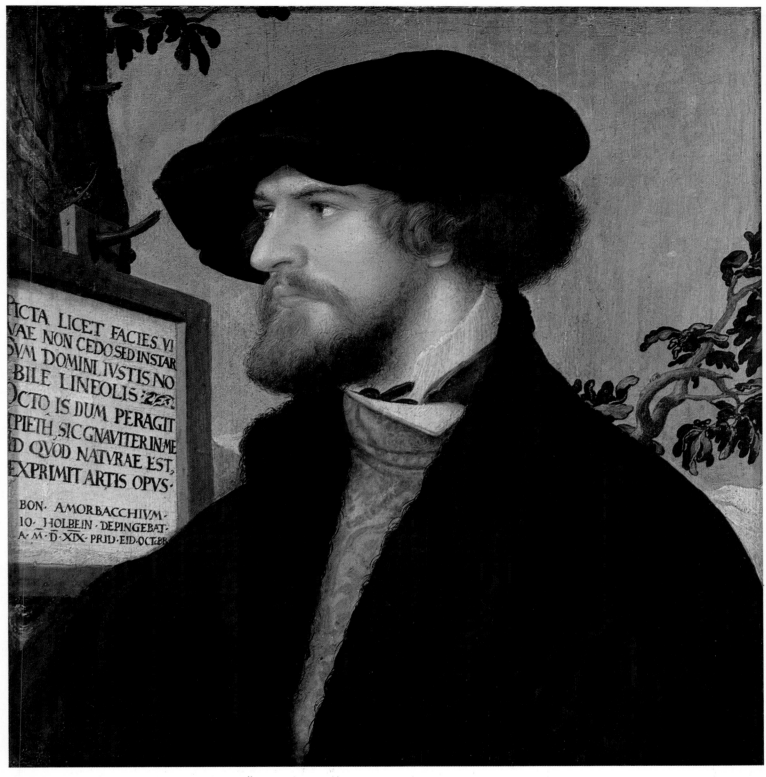

4. *Bonifacius Amerbach*. 1519. Basle, Öffentliche Kunstsammlung

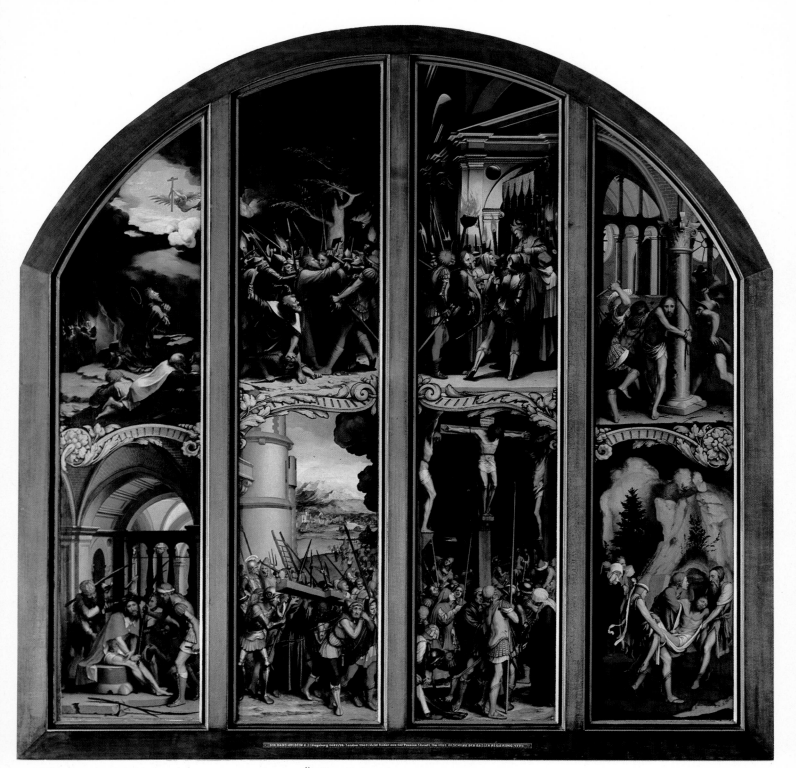

5. *The Passion of Christ.* About 1524. Basle, Öffentliche Kunstsammlung

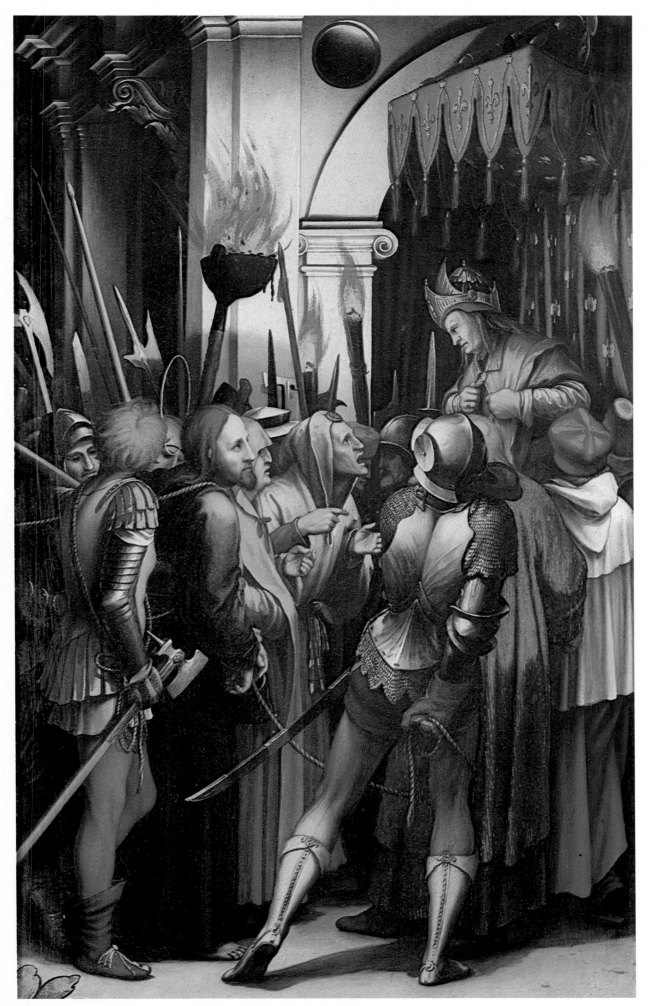

6. Detail of Plate 5

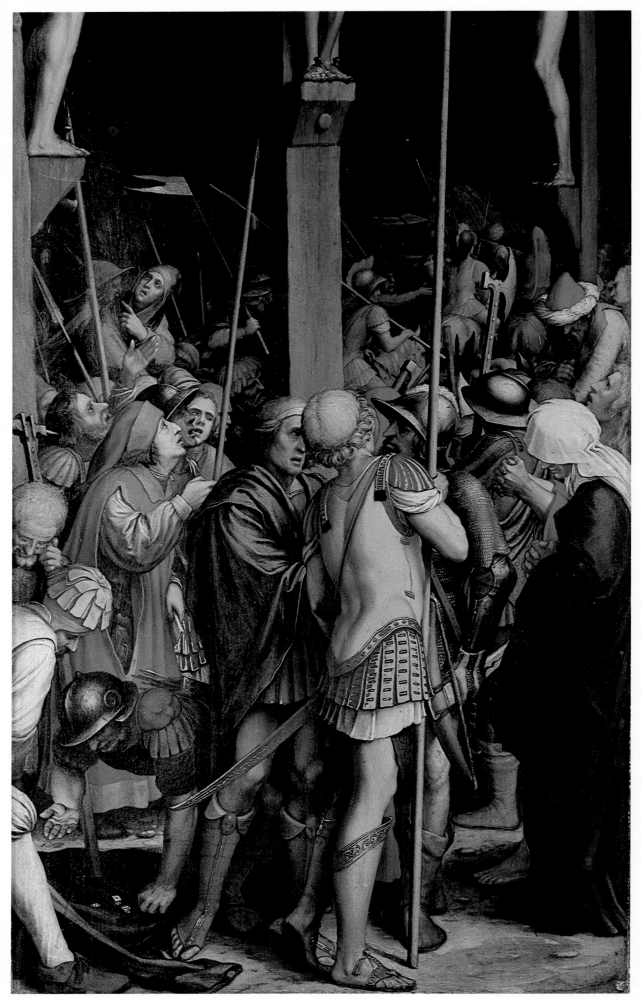

7. Detail of Plate 5

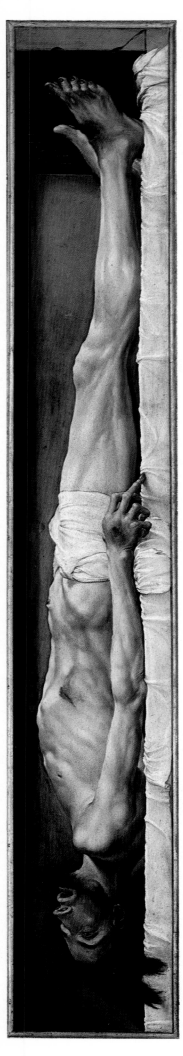

8. *Dead Christ*. 1521. Basle, Öffentliche Kunstsammlung

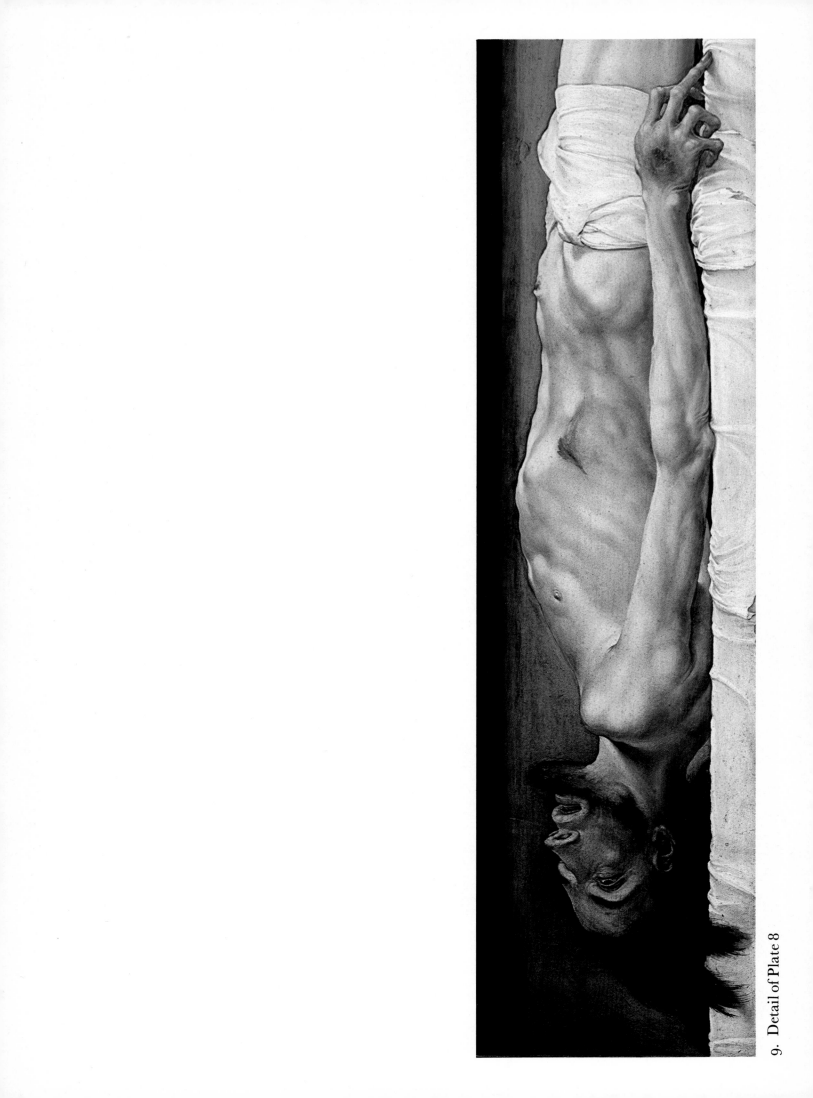

9. Detail of Plate 8

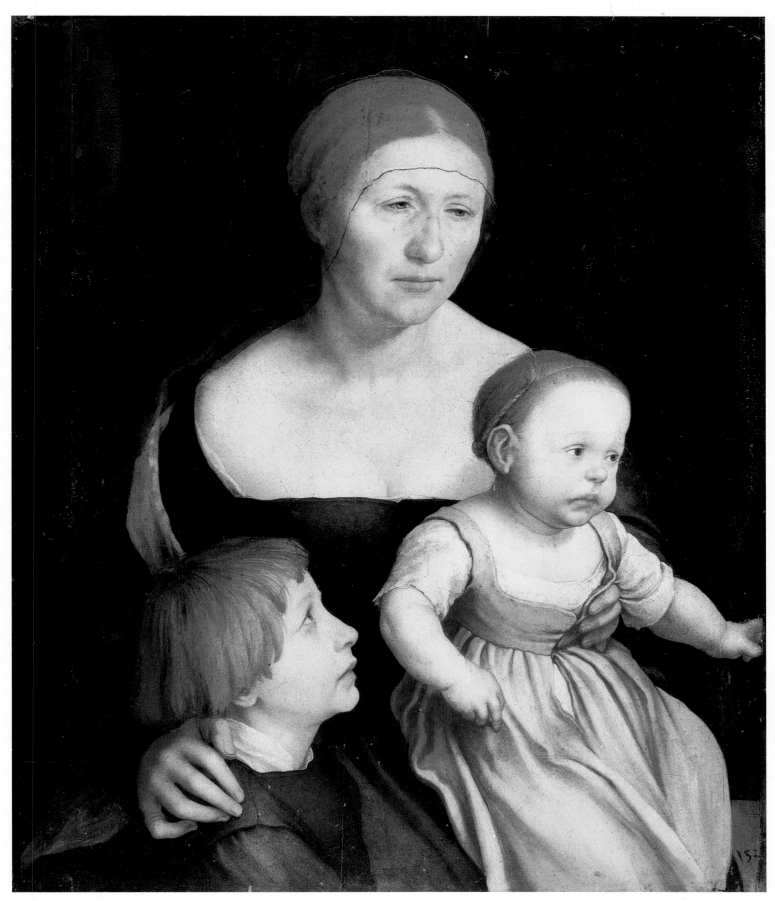

10. *The Artist's Family*. 1528. Basle, Öffentliche Kunstsammlung

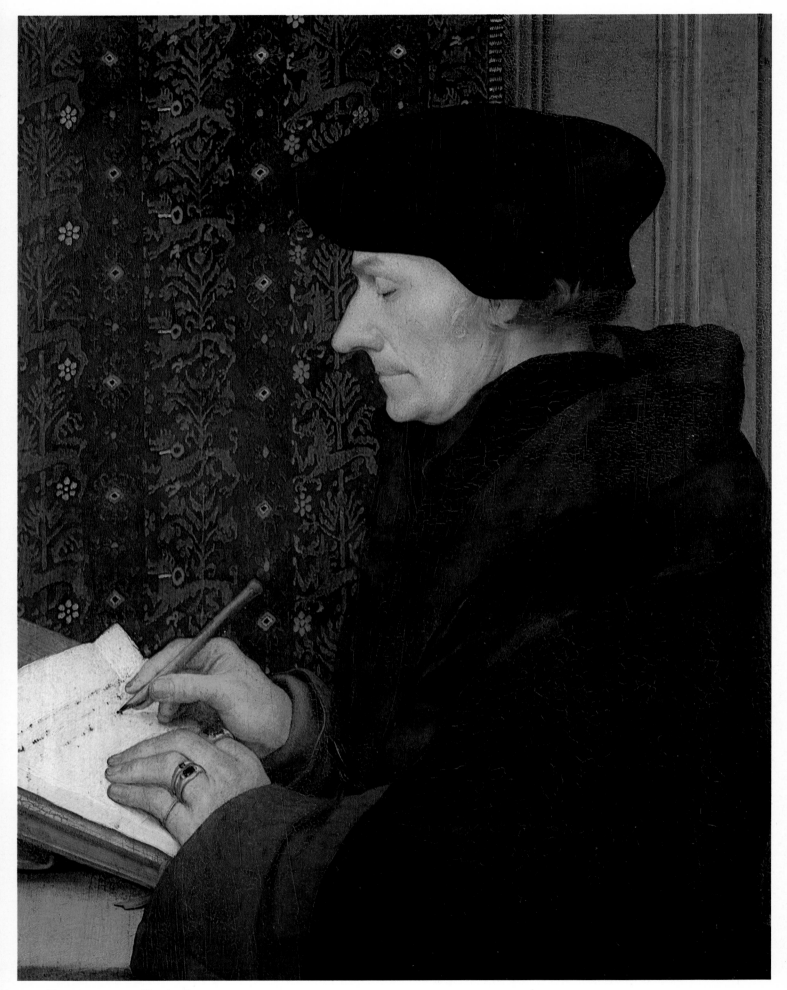

11. *Erasmus*. 1523. Paris, Louvre

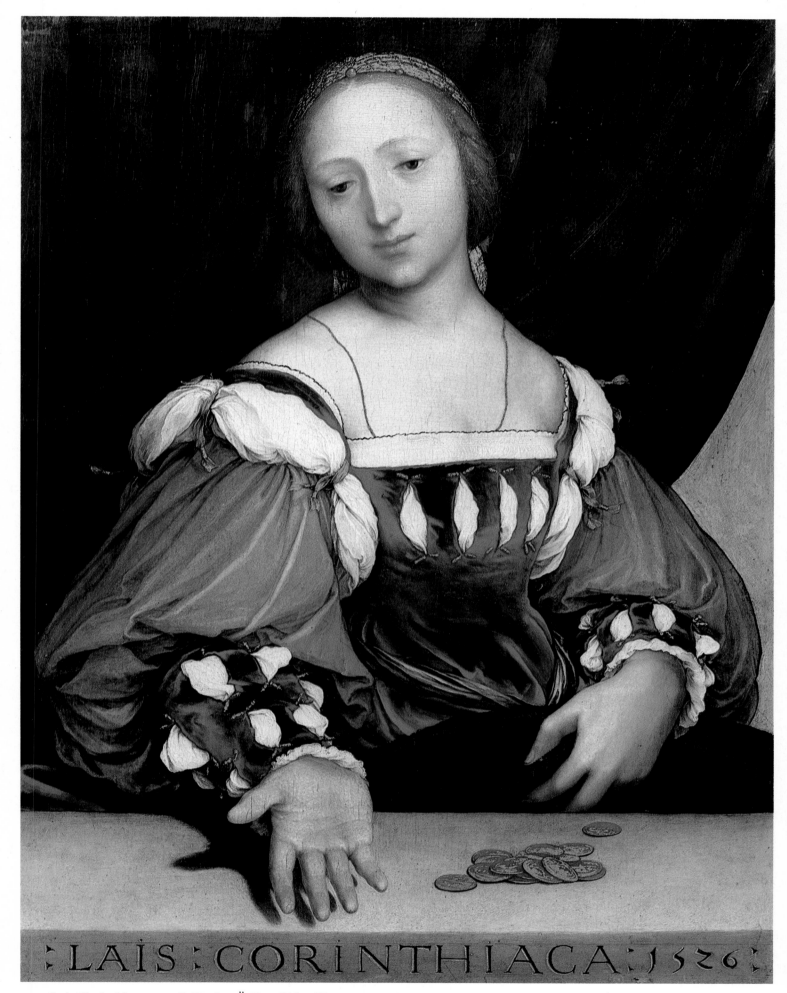

: LAIS : CORINTHIACA : 1526 :

12. *Lais Corinthiaca.* 1526. Basle, Öffentliche Kunstsammlung

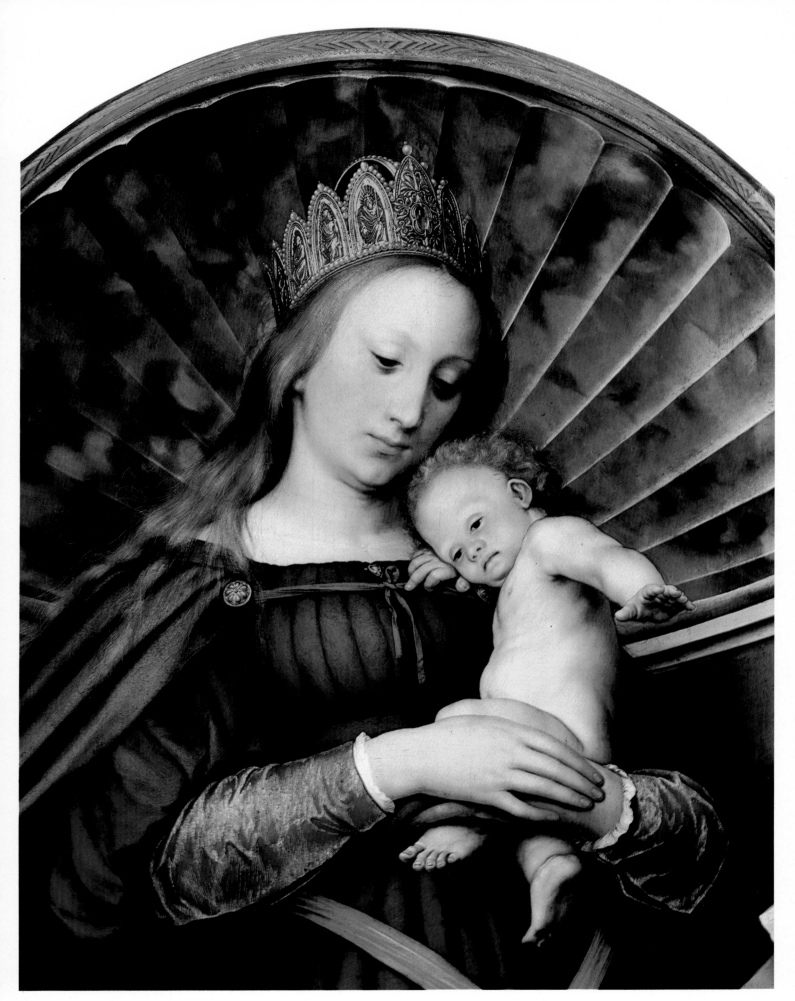

13. Detail of Plate 14

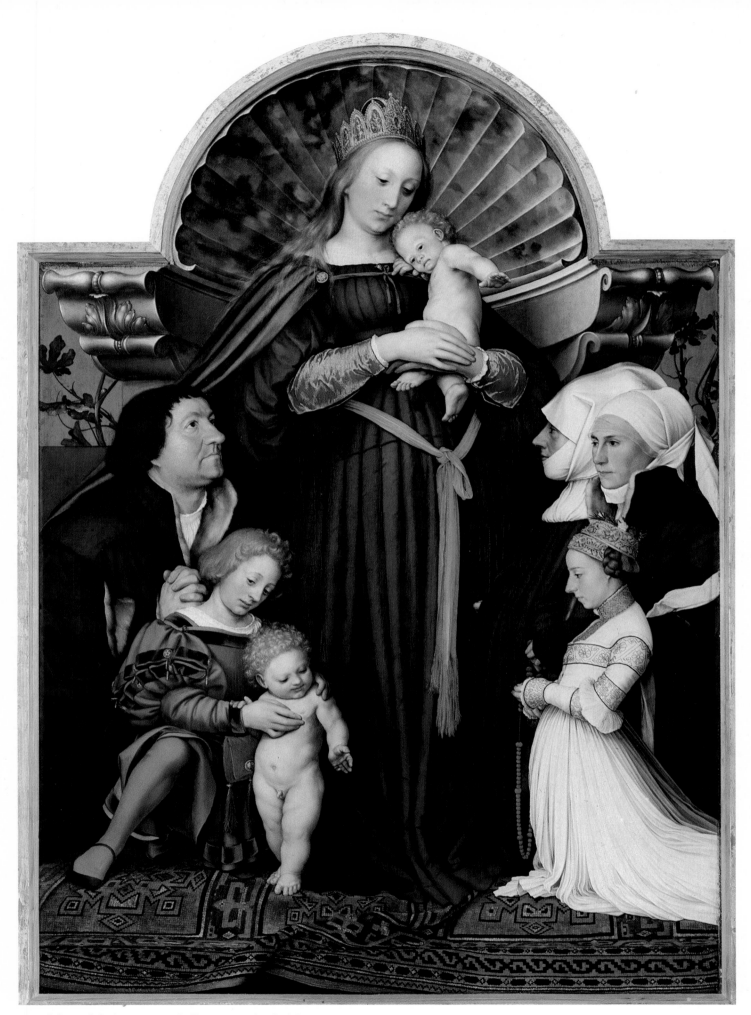

14. *Meyer Madonna.* 1526. Darmstadt, Schlossmuseum

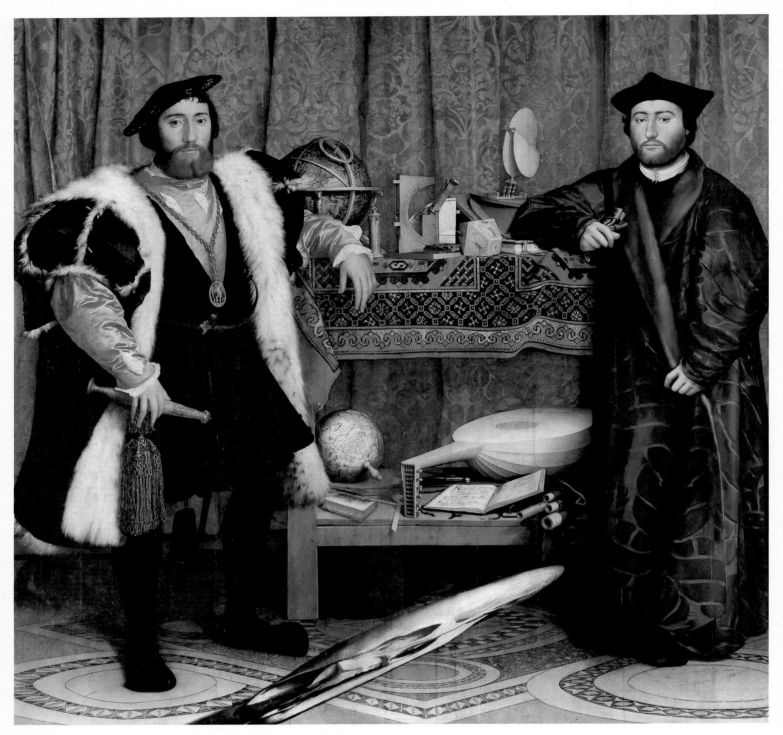

15. *The Ambassadors.* 1533. London, National Gallery

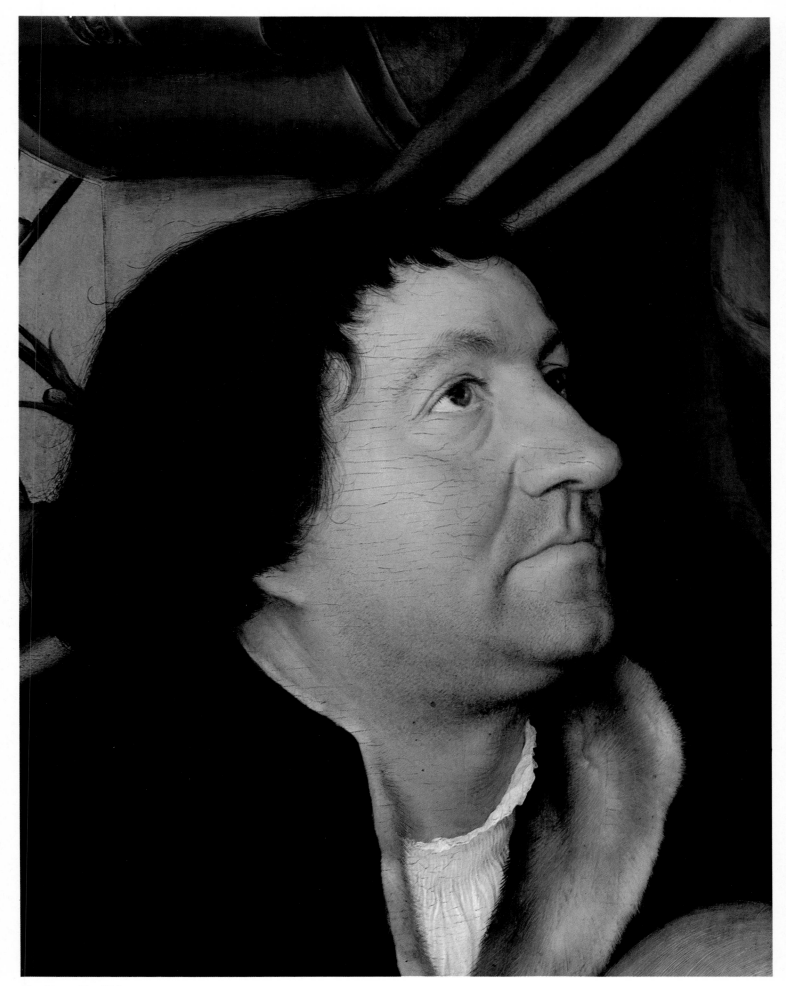

16. Detail of Plate 14

17. Detail of Plate 14

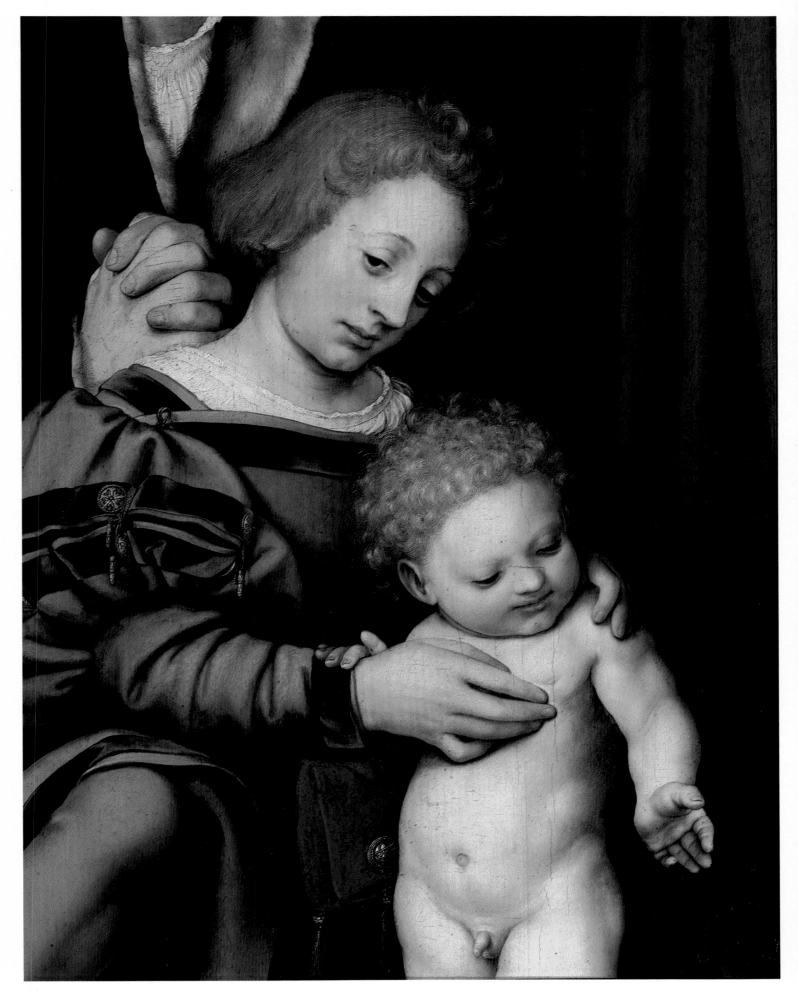

18. Detail of Plate 14

19. Detail of Plate 15

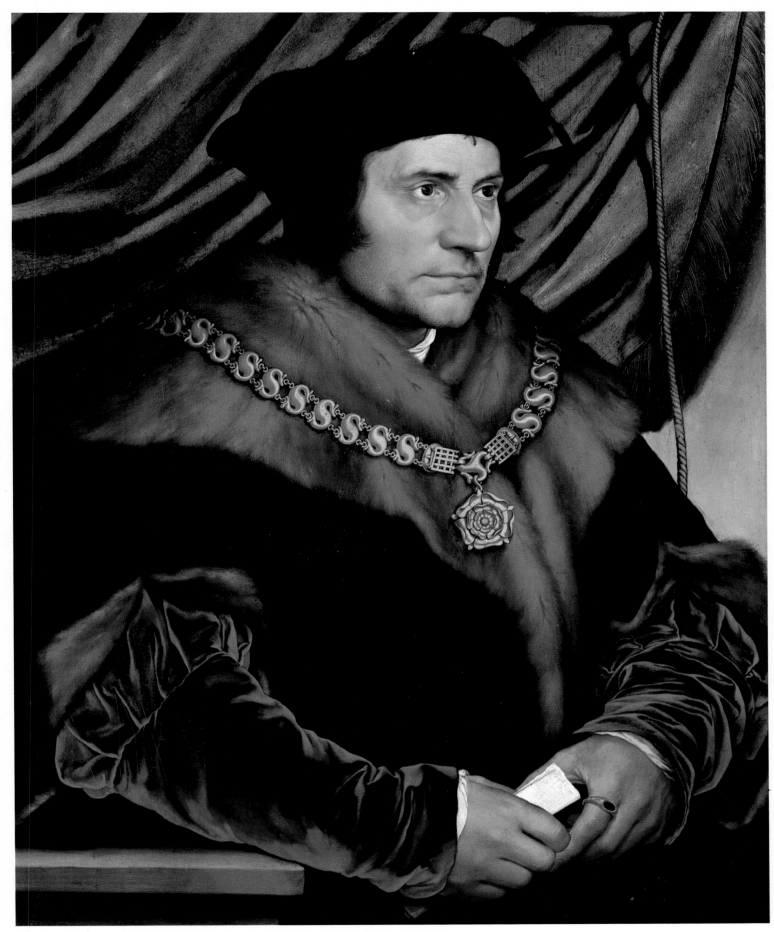

20. *Sir Thomas More.* 1527. New York, The Frick Collection

21. *Unknown Lady with a Squirrel and a Starling.* About 1528. Houghton Hall, Norfolk, The Marquess of Cholmondeley Collection

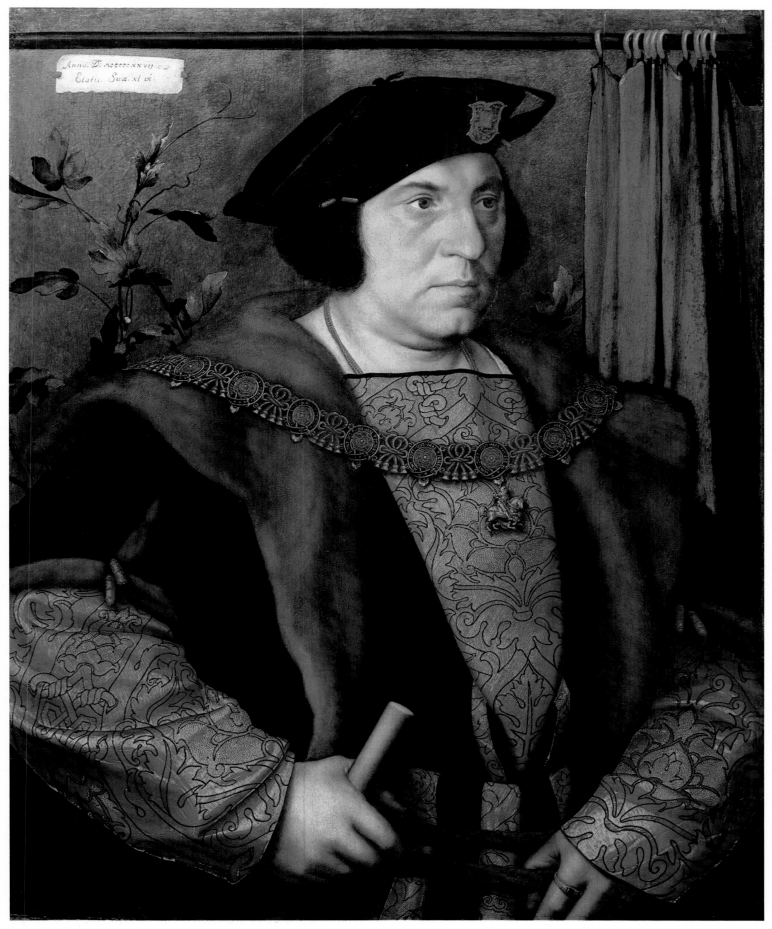

22. *Sir Henry Guildford.* 1527. Windsor, Royal Collection

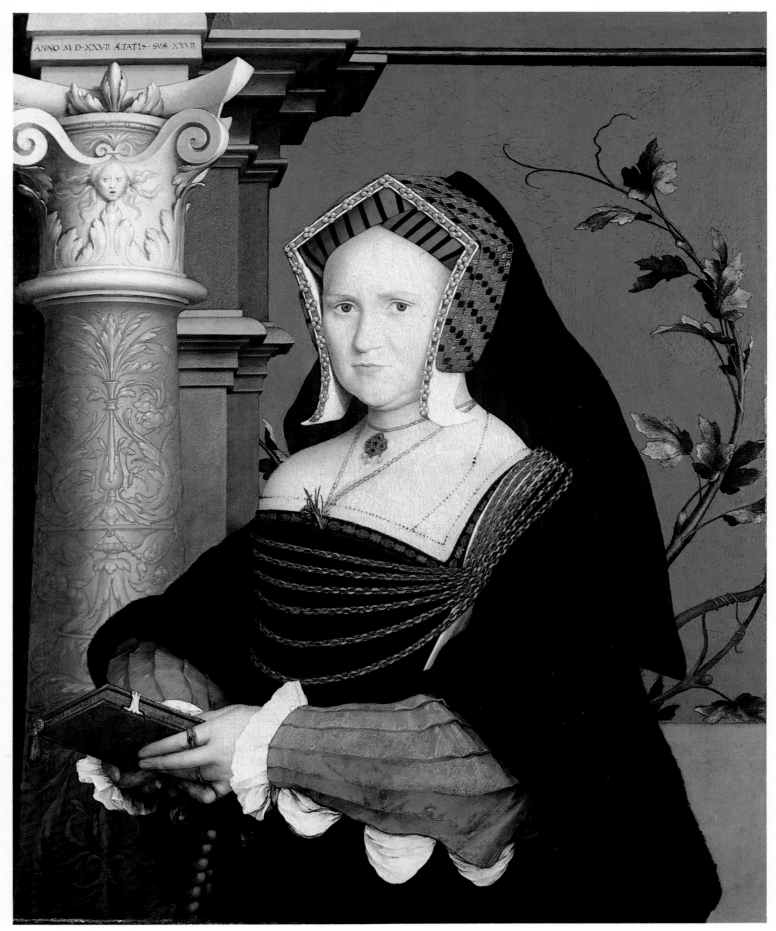

ANNO M D XXVII ÆTATIS SVÆ XXVII

23. *Lady Guildford.* 1527. St. Louis, City Art Museum

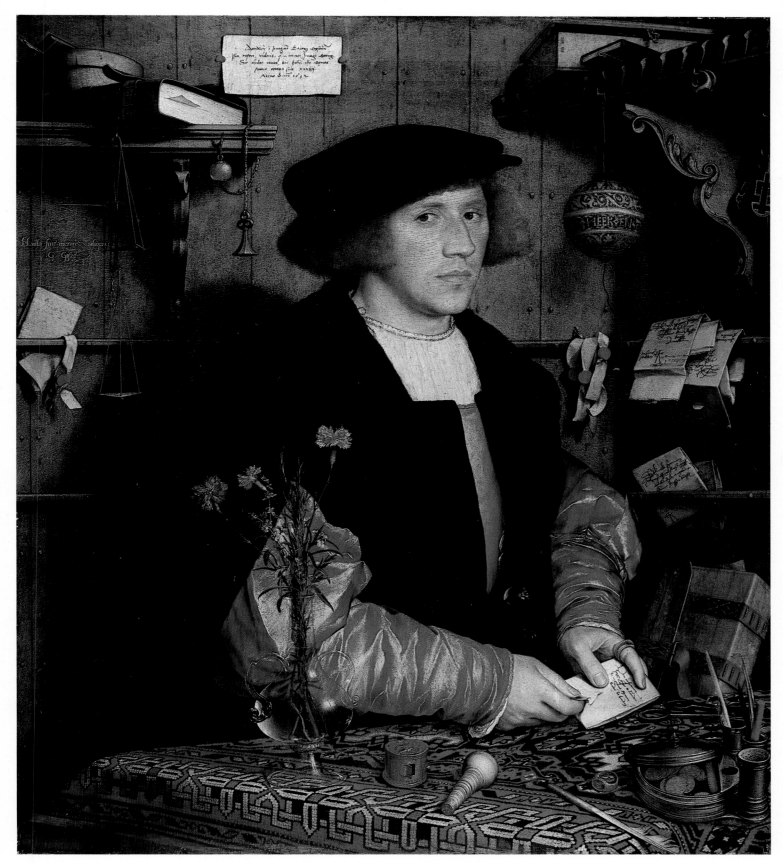

24. *Georg Gisze of Danzig.* 1532. Berlin, Staatliche Museum, Gemäldegalerie

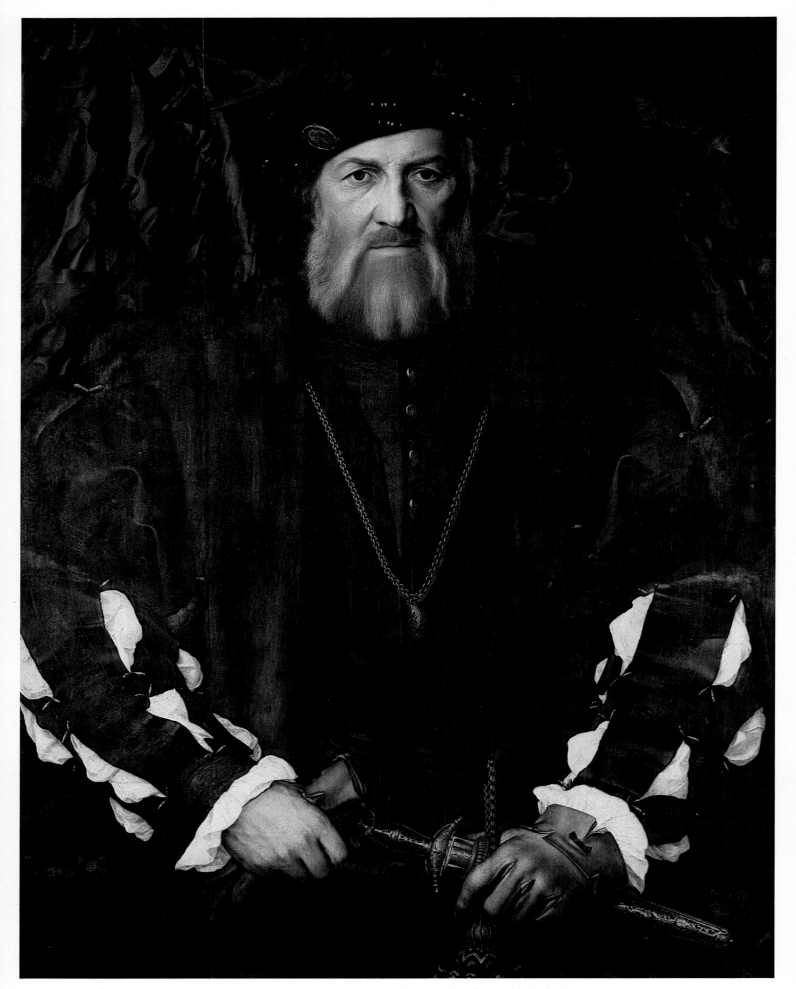

25. *Charles de Solier, Sire de Morette*. About 1534. Dresden, Staatliche Gemäldegalerie

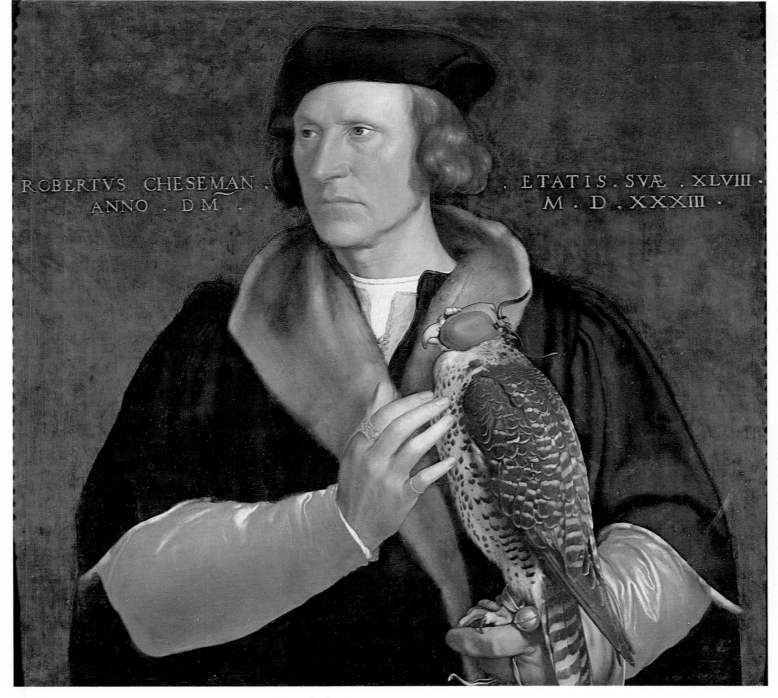

26. *Robert Cheseman*. 1533. The Hague, Mauritshuis

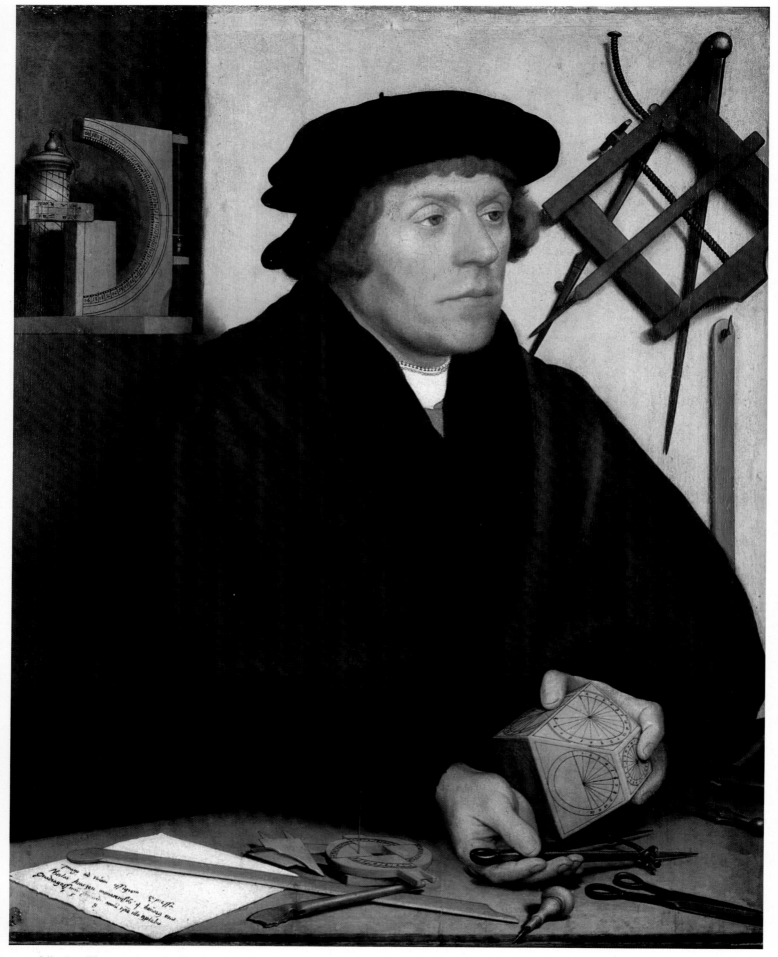

27. *Nicolas Kratzer.* 1528. Paris, Louvre

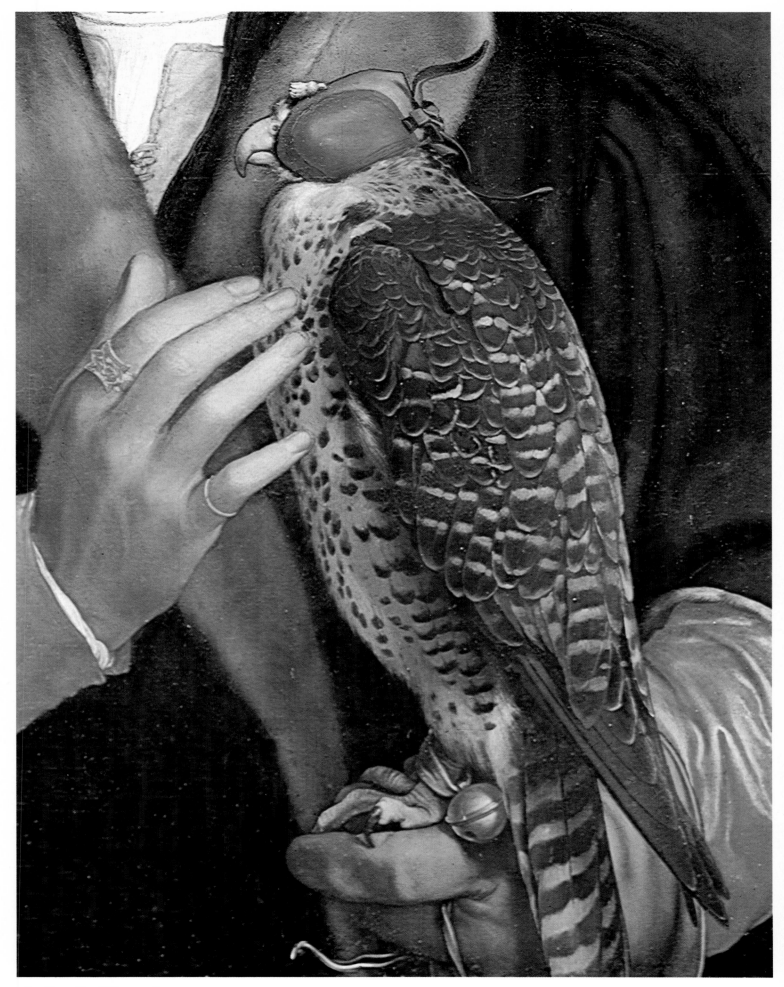

28. Detail of Plate 26

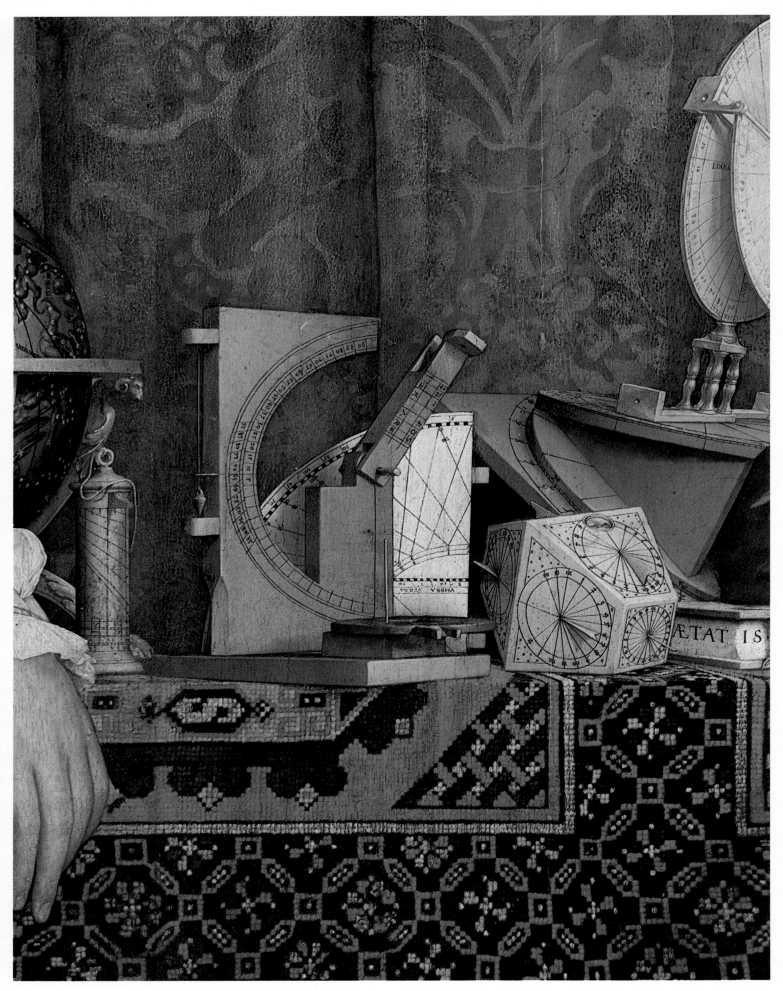

29. Detail of Plate 15

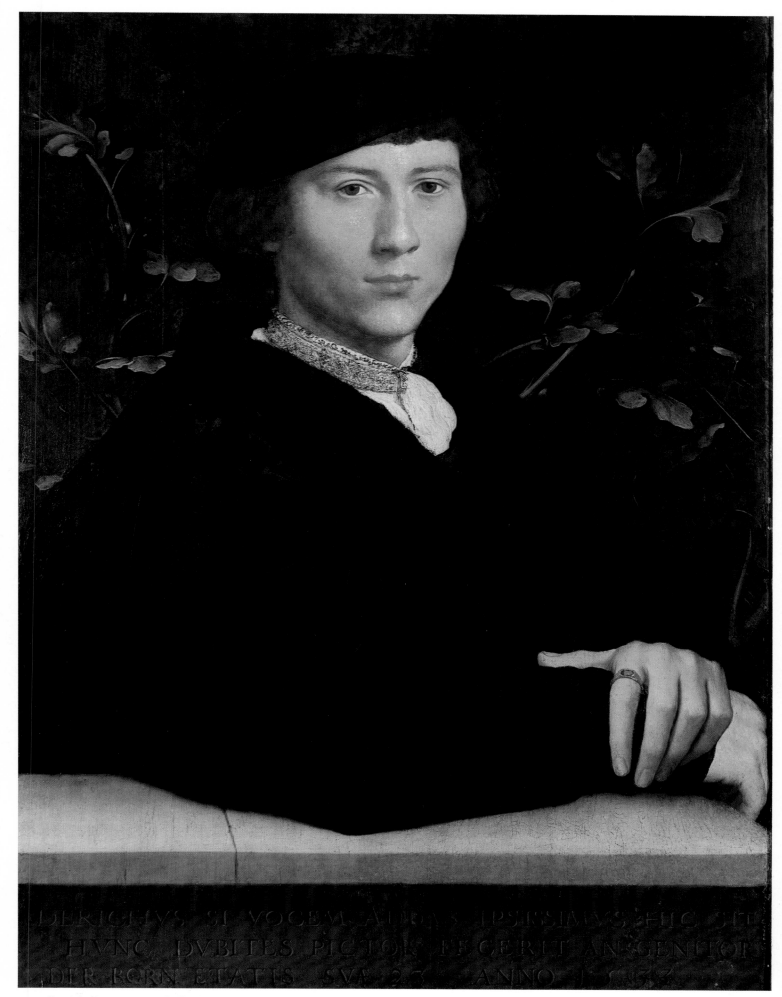

30. *Derich Born.* 1533. Windsor, Royal Collection

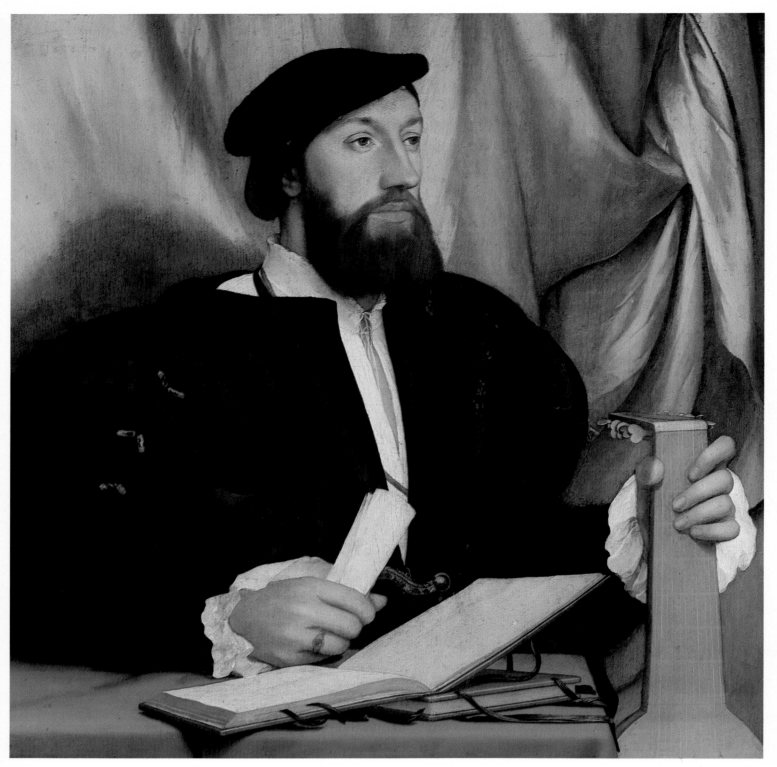

31. *Unknown Gentleman with Music Books and Lute*. About 1534. Berlin, Staatliche Museum, Gemäldegalerie

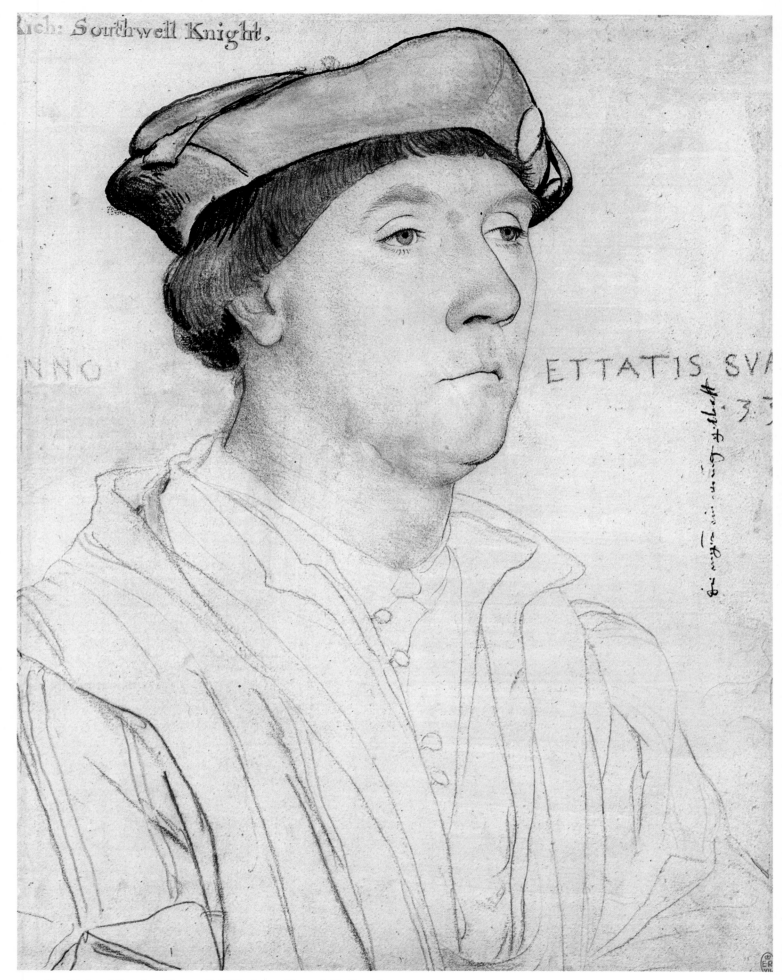

Rich: Southwell Knight.

ANNO ETTATIS SVA
33

32. *Sir Richard Southwell.* 1536. Windsor, Royal Collection

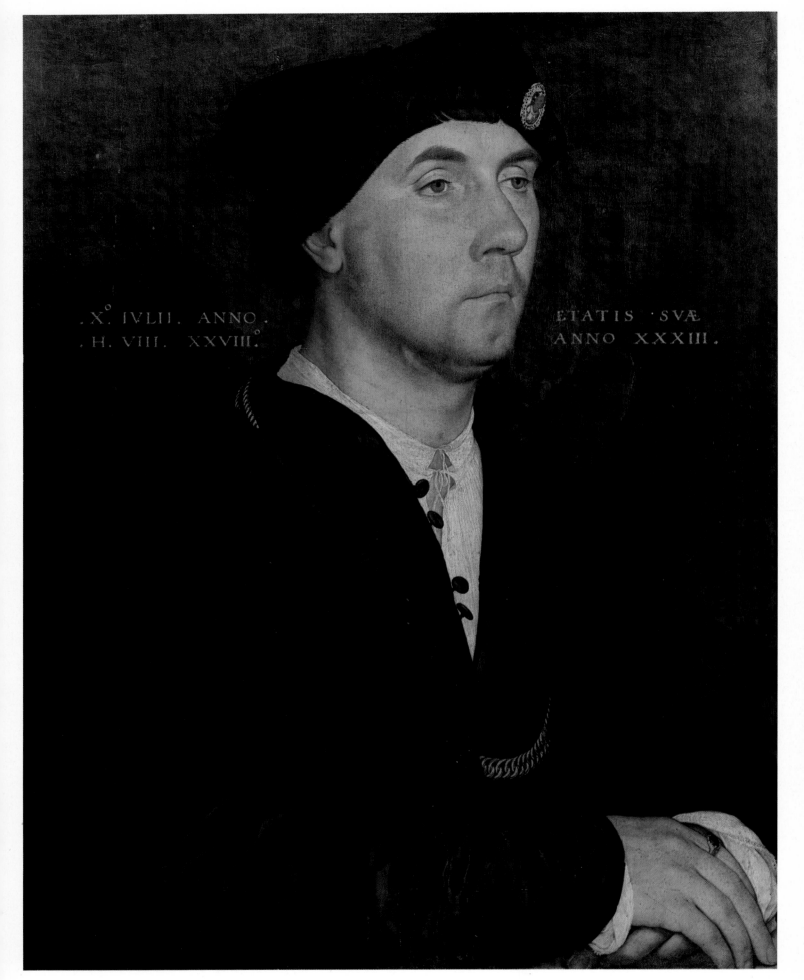

.X̊. IVLII. ANNO.
.H. VIII. XXVIII̊.

ETATIS ·SVÆ
ANNO XXXIII.

33. *Sir Richard Southwell*. 1536. Florence, Uffizi

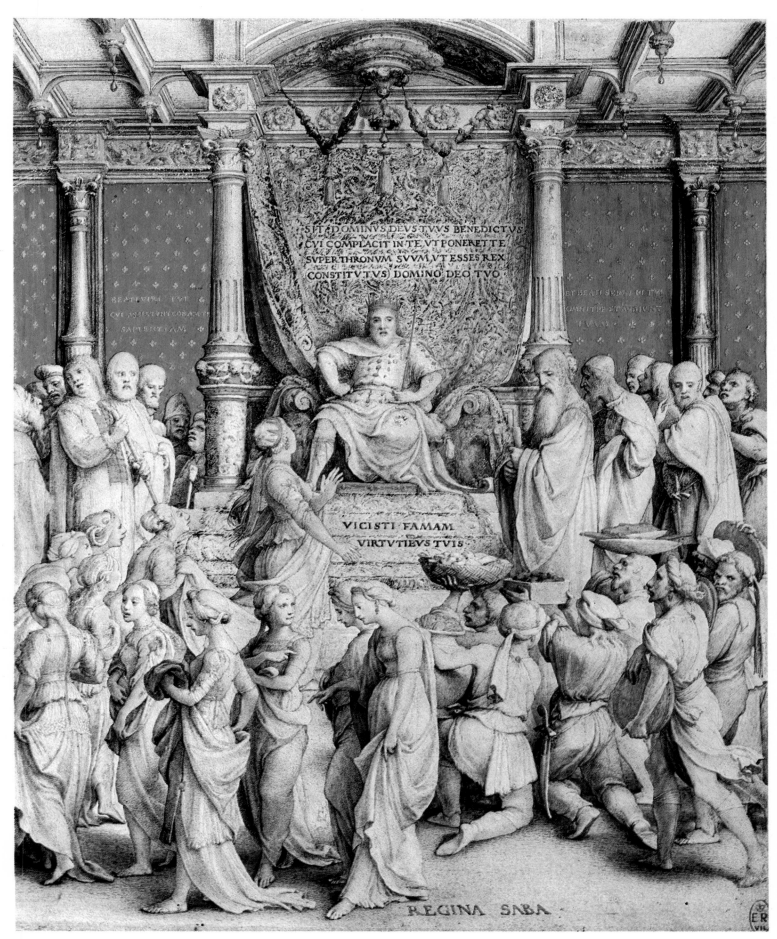

34. *Solomon Receiving the Homage of the Queen of Sheba*. About 1535. Windsor, Royal Collection

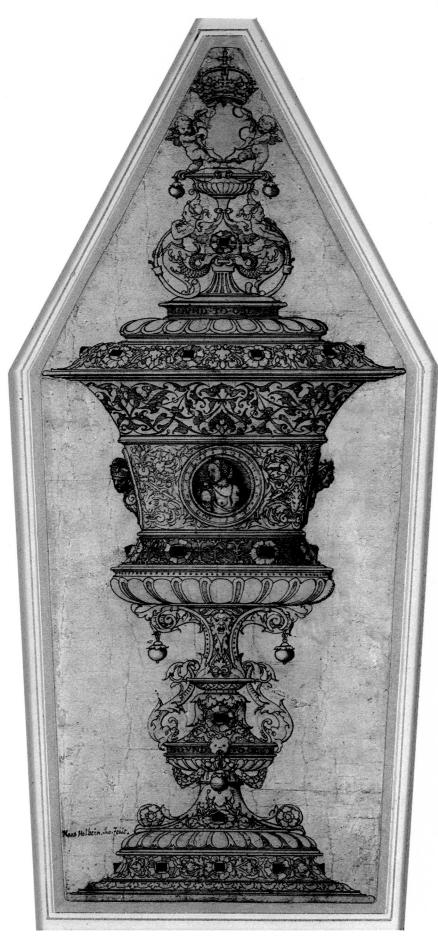

35. *Jane Seymour's Cup*. About 1536. Oxford, Ashmolean Museum

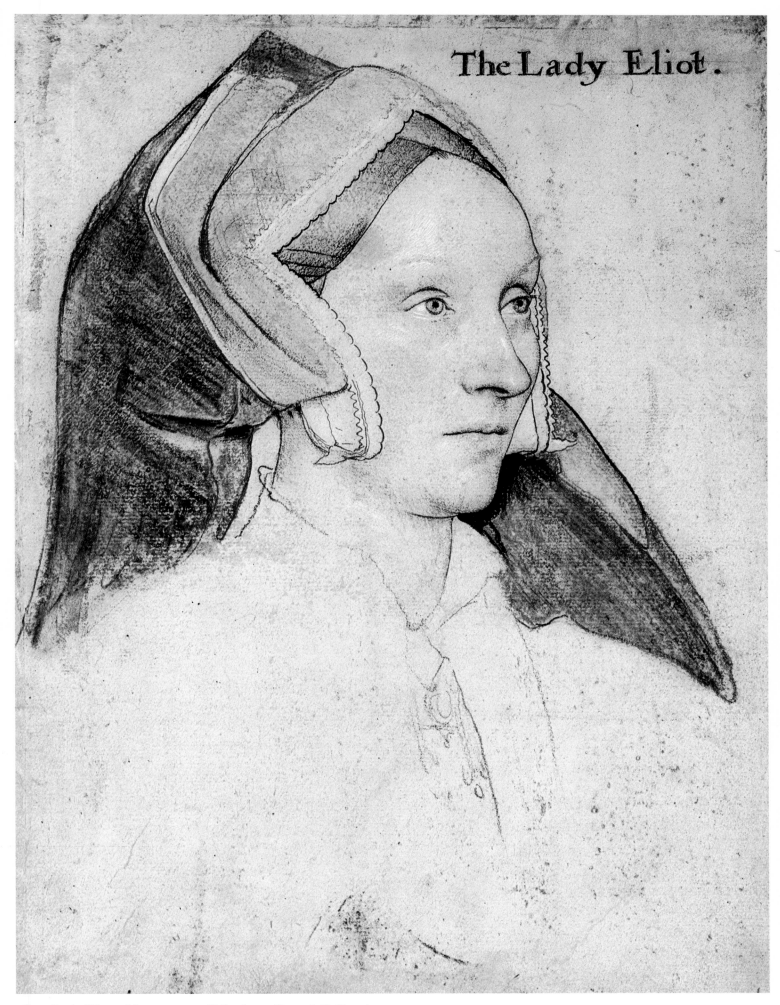

The Lady Eliot.

36. *Lady Elyot*. About 1531. Windsor, Royal Collection

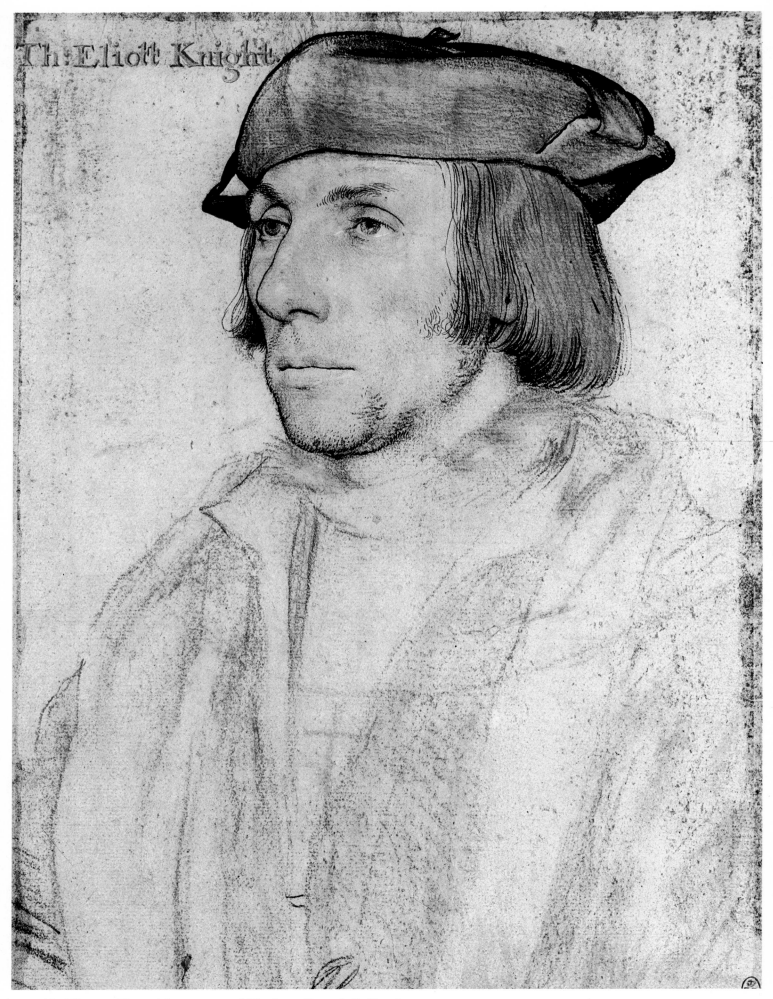

Th:Eliott Knight.

37. *Sir Thomas Elyot.* About 1531. Windsor, Royal Collection

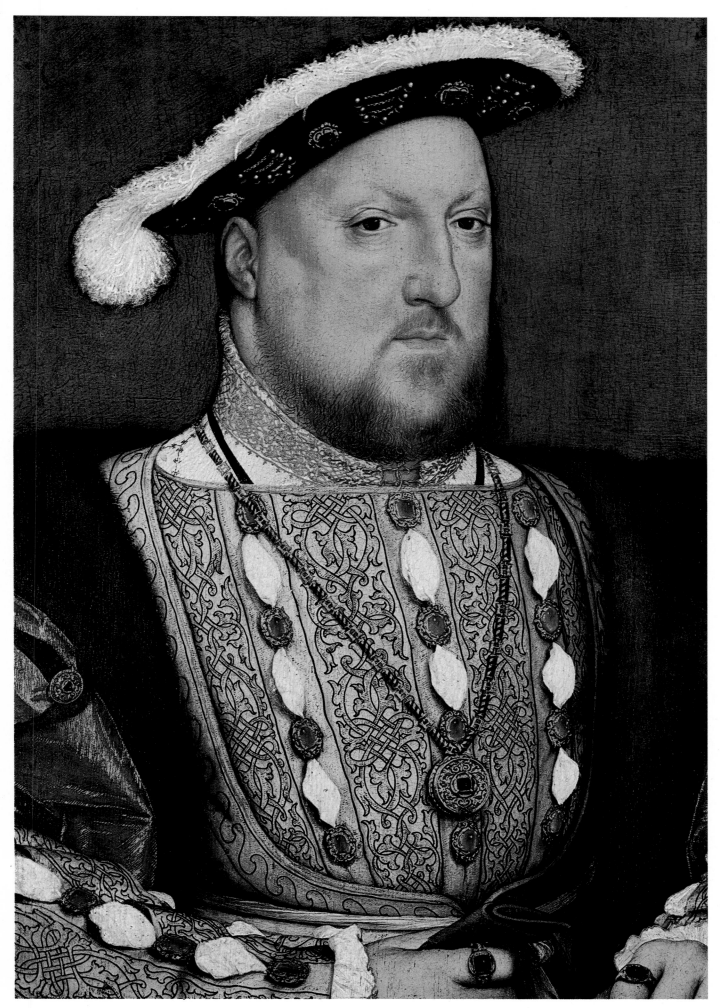

38. *Henry VIII*. About 1536. Lugano-Castagnola, Thyssen-Bornemisza Collection

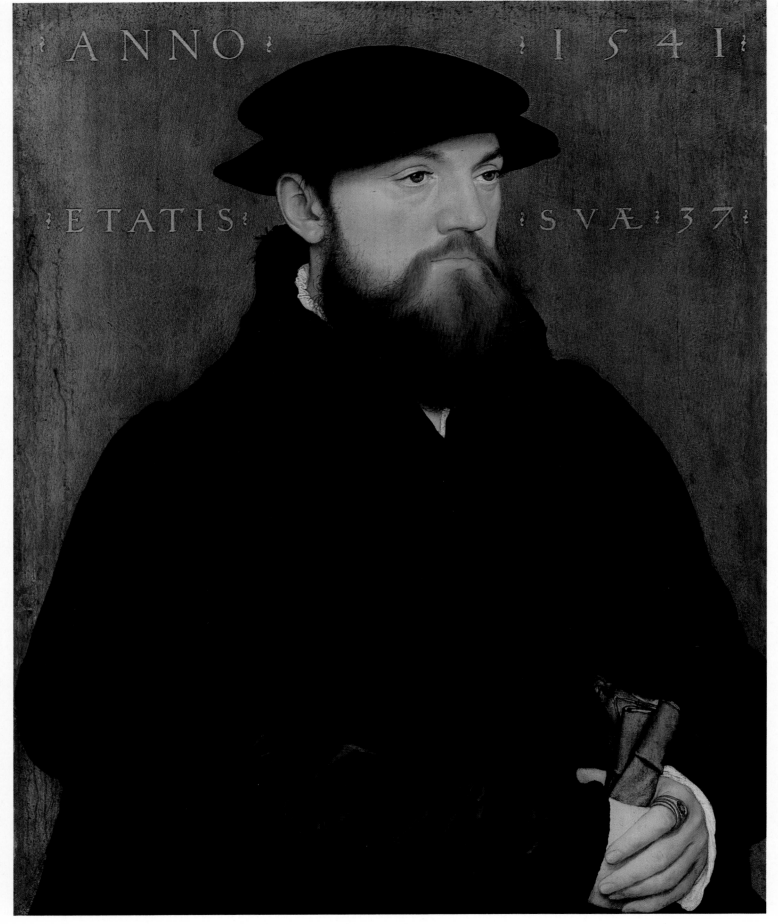

39. *De Vos van Steenwijk*. 1541. Berlin, Staatliche Museum, Gemäldegalerie

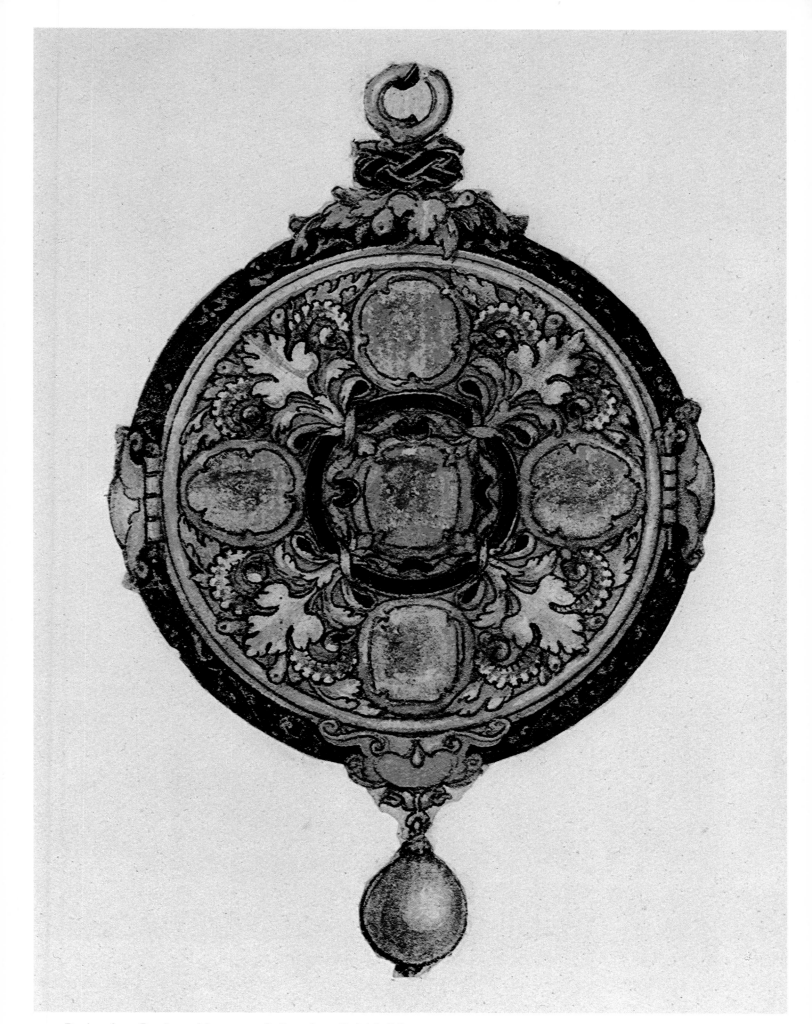

40. *Design for a Pendant.* About 1536. London, British Museum

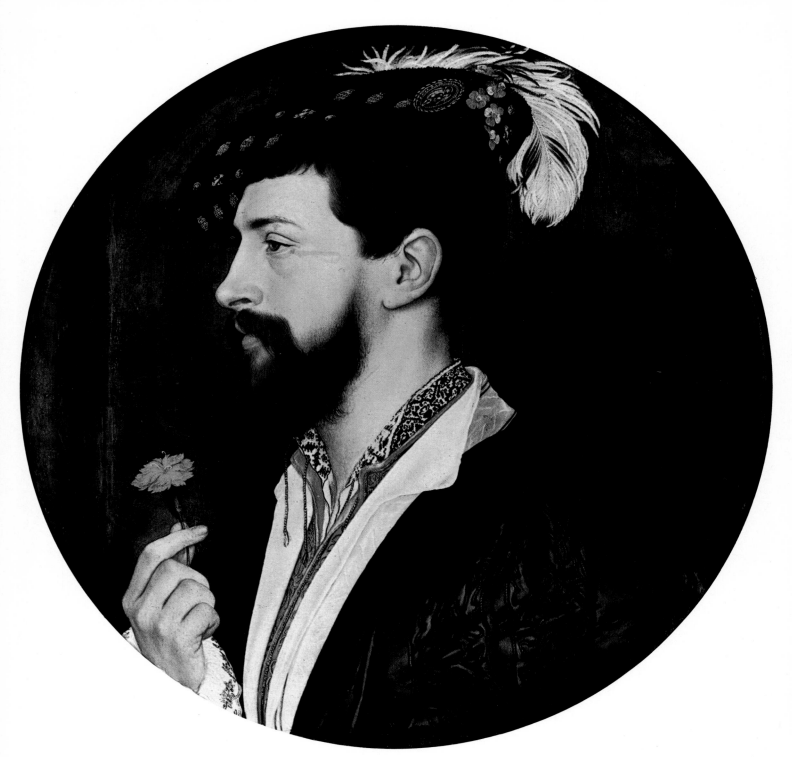

41. *Simon George of Quocote*. About 1535. Frankfurt, Städelsches Kunstinstitut

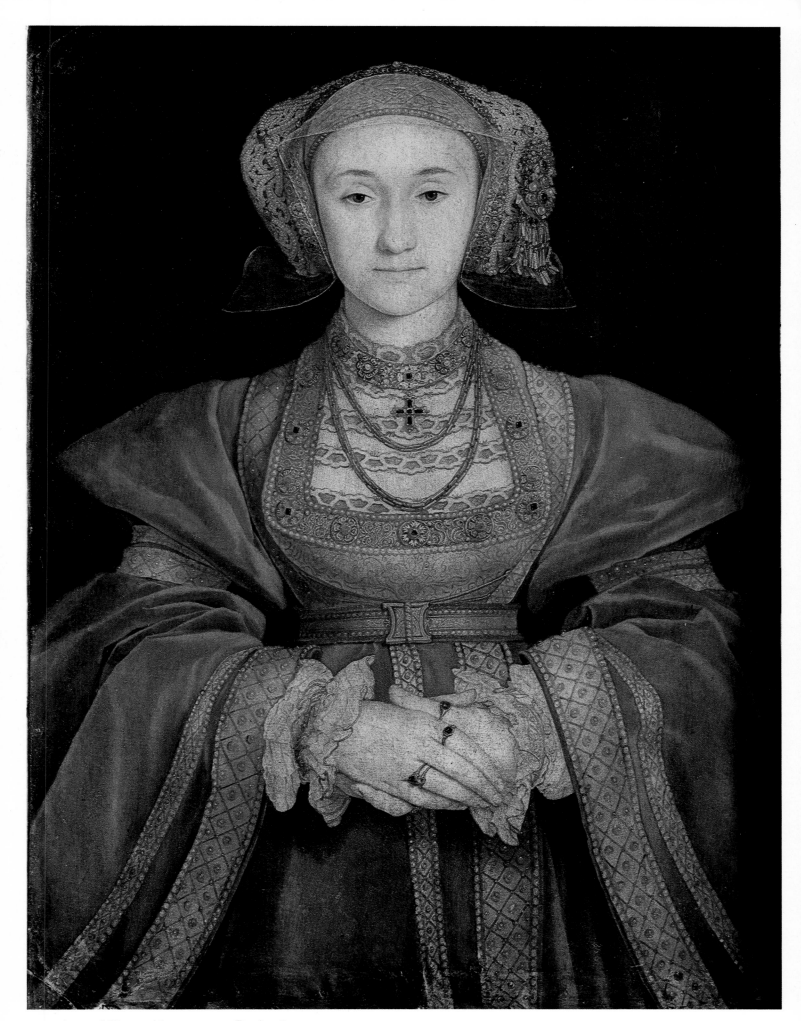

42. *Anne of Cleves*. About 1539. Paris, Louvre

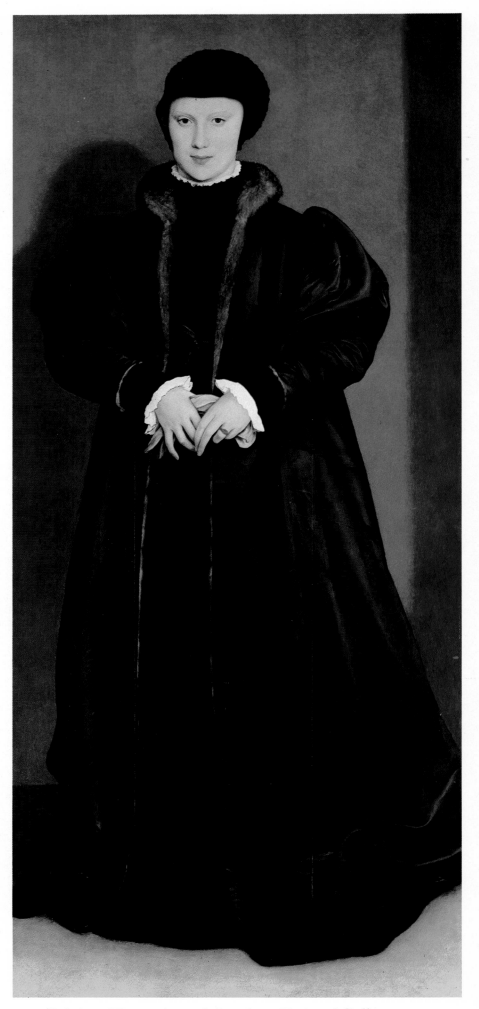

43. *Christina of Denmark.* 1538. London, National Gallery

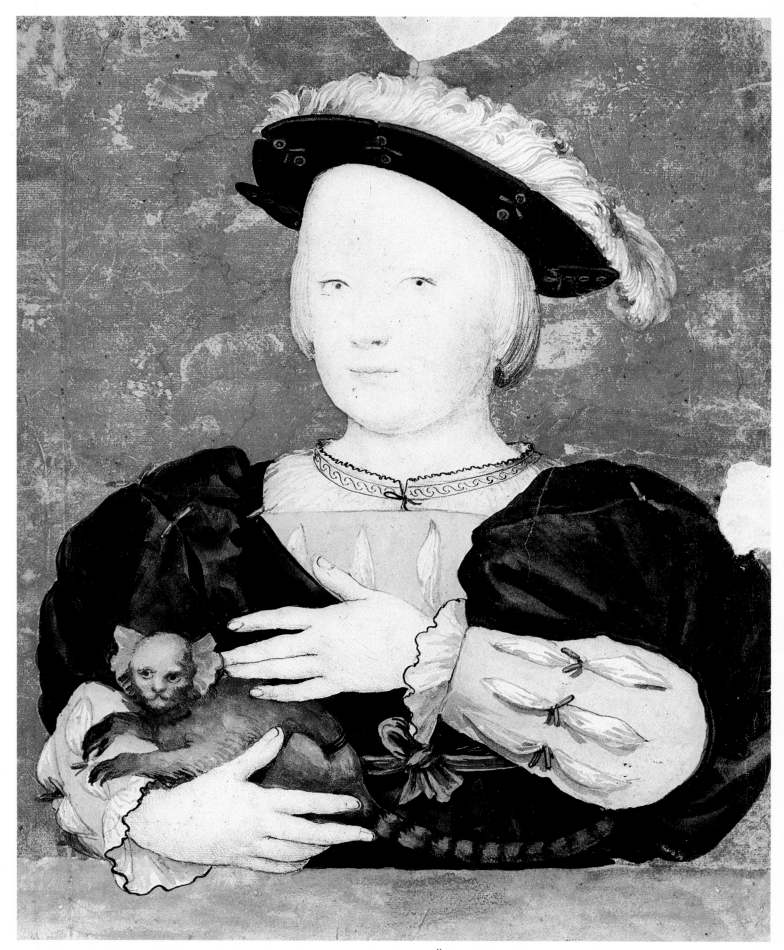

44. *Edward, Prince of Wales, with Monkey*. About 1541–2. Basle, Öffentliche Kunstsammlung

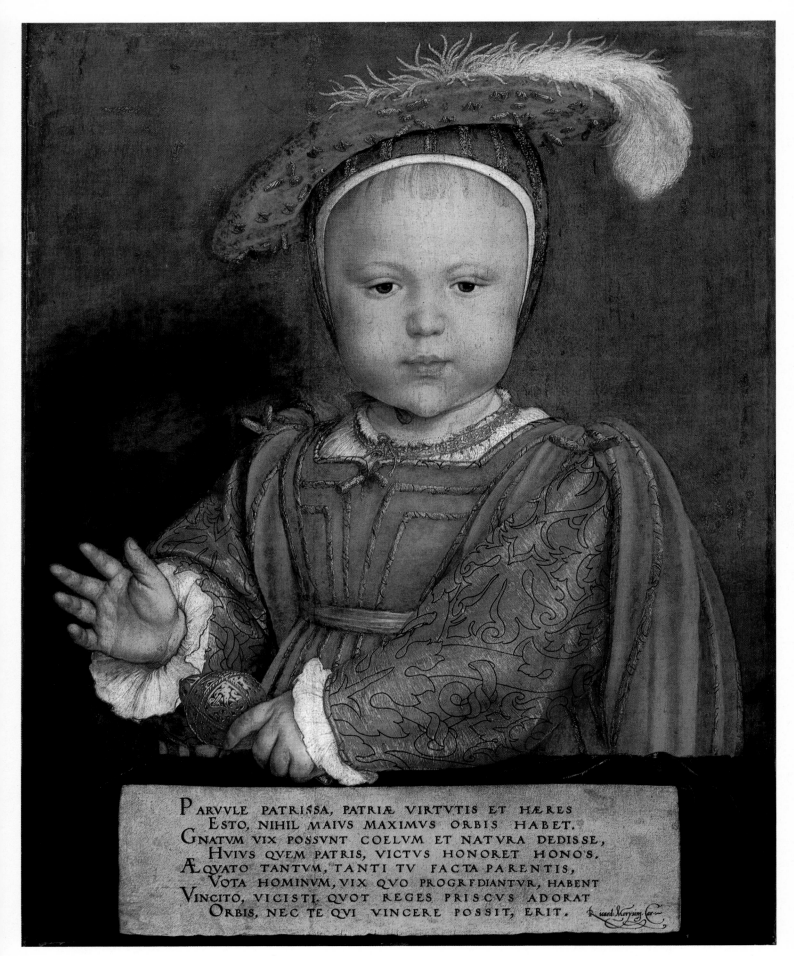

PARVVLE PATRISSA, PATRIÆ VIRTVTIS ET HÆRES
ESTO, NIHIL MAIVS MAXIMVS ORBIS HABET.
GNATVM VIX POSSVNT COELVM ET NATVRA DEDISSE,
HVIVS QVEM PATRIS, VICTVS HONORET HONOS.
ÆQVATO TANTVM, TANTI TV FACTA PARENTIS,
VOTA HOMINVM, VIX QVO PROGREDIANTVR, HABENT
VINCITO, VICISTI. QVOT REGES PRISCVS ADORAT
ORBIS, NEC TE QVI VINCERE POSSIT, ERIT.

Ricard. Morysin. Car.

45. *Edward, Prince of Wales.* 1539. Washington, National Gallery of Art, Andrew W. Mellon Collection

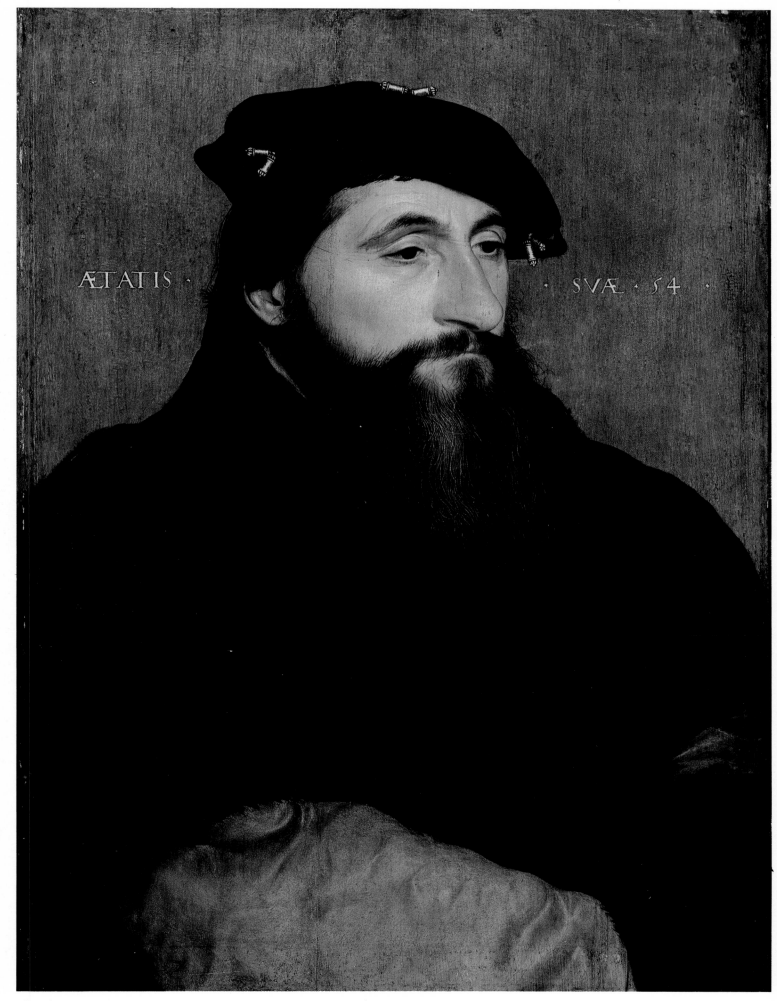

ÆTATIS · · SVÆ · 54

46. *Anton the Good, Duke of Lorraine.* 1543. Berlin, Staatliche Museum, Gemäldegalerie

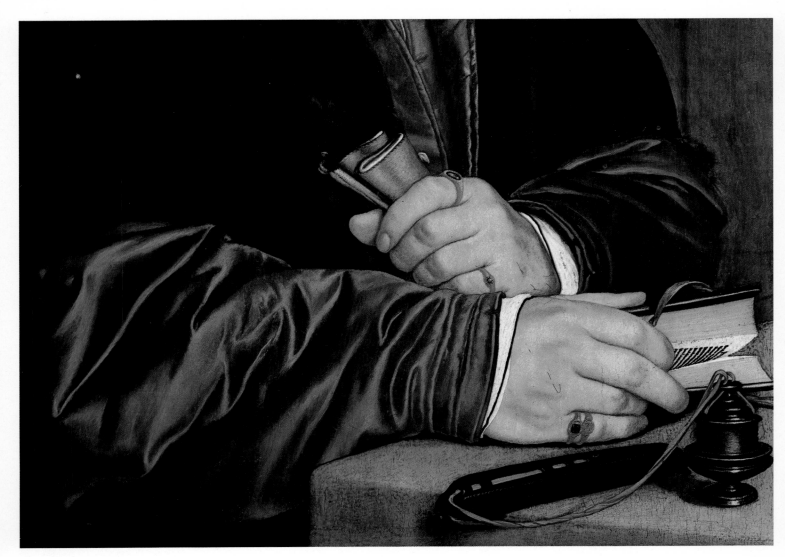

48. Detail of Plate 47

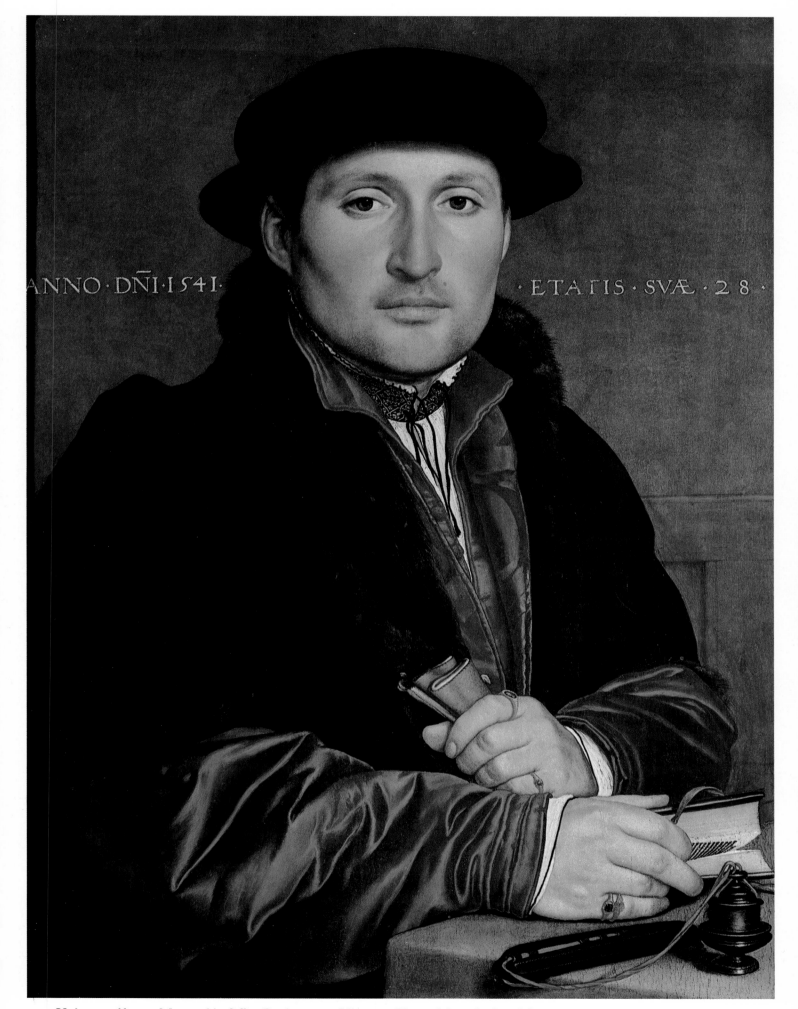

ANNO · DÑI · 1541 · ETATIS · SVÆ · 2 8 ·

47. *Unknown Young Man at his Office Desk*. 1541. Vienna, Kunsthistorisches Museum